SURREY
EXECUTIONS

SURREY
EXECUTIONS

A Complete List of those Hanged in the
County during the Nineteenth Century

MARTIN BAGGOLEY

AMBERLEY

This book is for Allen, who chose Surrey

First published 2011

Amberley Publishing
Cirencester Road, Chalford,
Stroud, Gloucestershire, GL6 8PE

www.amberleybooks.com

Copyright © Martin Baggoley, 2011

The right of Martin Baggoley to be identified as the Author
of this work has been asserted in accordance with the
Copyrights, Designs and Patents Act 1988.

British Library Cataloguing in Publication Data.
A catalogue record for this book is available from the British Library.

ISBN 978 1 84868 299 3

Typesetting and Origination by Amberley Publishing.
Printed in Great Britian.

INTRODUCTION

IN EIGHTEENTH-CENTURY SURREY, most of the county's condemned criminals were executed on Kennington Common, but court records confirm that others were hanged in the towns of Kingston and Guilford, on Peckham Common, Bagshot Heath and Richmond Hill, and in St George's Fields at Southwark. Towards the close of the century however, it was decided to build a new gaol to hold three hundred prisoners and which would also serve as the county's permanent place of execution. George Gwilt, the county architect and surveyor, designed the building and oversaw its construction between 1791 and 1799. The Surrey County Gaol, also referred to as the New Gaol, became more widely known by the name of the Southwark thoroughfare on which it stood, Horsemonger Lane. At the time the north east of the county shared a common border with the City of London and it was not until 1889 that this area became part of the new County of London.

The scaffold was erected on the flat roof of the gaol's gatehouse, thereby providing spectators with an excellent view of the executions, which were then carried out in public. The first took place on 4 April 1800 and the last to be carried out in public was on 15 October 1867, after which the condemned were dispatched within the gaol's walls, away from the gaze of crowds that often totalled many thousands. There was only one exception when, in 1818, George Chennell and his accomplice William Chalcraft were executed at Godalming, close to the scene of their crime, the murder of Chennell's father and his housekeeper.

It was decided to close the gaol in 1878, after which it was demolished and a children's playground built on the site. Several hangmen officiated at the gaol and these were William Brunskill, John Langley, Jeremy Botting, Thomas Foxen, William Calcraft and William Marwood.

Wandsworth Prison opened in 1851, replacing the smaller gaols in the county such as those at Guildford and Kingston. Designed by Birmingham architect D. Hill, it could hold seven hundred prisoners, each occupying a separate cell. Executions did not take place there immediately and the first was carried out on 8 October 1878, after the closure of Horsemonger Lane, as were the subsequent executions described

in the book. William Marwood officiated at the first of these and in the remaining years of the century, he was followed by Bartholomew Binns, James Berry and James Billington.

I have listed all of the executions carried out in the county in the nineteenth century and have described some of the crimes committed by those who were hanged. The account begins in the era of the 'Bloody Code', a time when there were more than two hundred capital crimes. The executions described in the opening years of the century therefore relate to offenders guilty of crimes such as burglary, coining, rape, returning from transportation, and sheep theft besides those convicted of murder. As the century progressed, the number of crimes which could lead to the gallows decreased gradually and in 1836, burglar William Harley was the last individual to hang for a crime other than murder.

Throughout the early years of the century, there was also a debate, quite separate from that calling for the total abolition of capital punishment, which centred on the issue of public executions. Charles Dickens witnessed the execution of the Mannings', outside Horsemonger Lane Gaol in 1849, which led to his famous letter to *The Times*, calling for an end to these public spectacles and what he considered to be the scandalous behaviour of the crowds attending them. This proved to be a significant contribution to that debate.

In researching the book, I have examined official archives, where available I have read original trial transcripts and I have also referred to contemporary newspaper accounts. Unfortunately, complete records from the early years of the nineteenth century have not survived intact in all cases and there are conflicting accounts of the crimes, the sentences passed and the names of those executed. However, where there is apparent confusion, I have used the details contained in the *Register of Deaths in the County Gaol, 13 August 1798–15 August 1878*. This was completed by staff at the gaol and although several pages are missing, those from the early years survive. It is held at the Surrey History Centre at Woking and I am grateful to the staff there, at the National Archives in Kew and at the Newspaper Library in Colindale for the help I have been given in writing the book.

The
Executions

1800

The first executions on the roof of the New Gaol took place on 4 April. Thomas Harkwell, convicted of high treason for coining, was hanged with four others including two burglars, William Lee and Charles Edlin. Edlin had appeared at the Old Bailey four years earlier and stood trial for another burglary when the main crown witness was a former accomplice. The jury had given him the benefit of the doubt and acquitted him on that occasion.

Valentine Middleton and George Hooker, who also went by the name of John Slater, were long-time criminal associates and were arrested following a series of robberies committed throughout the county. Hooker had been convicted of a highway robbery committed on 9 August 1799 at Wimbledon, for which he had been sentenced to be transported to Botany Bay for six years. However, he escaped and made his way back to his old haunts and was thus sentenced to death for returning from transportation.

As the condemned men were being positioned on the scaffold, Middleton commented to the officials gathered there that it reminded him very much of a pigeon loft.

Despite his death, Middleton would feature prominently in another court case heard later in the year, when on 11 December, before the Court of King's Bench at the Guildhall the plaintiff, wine-cooper Mr Cook claimed that he was owed £13 3s 10d by Middleton's wealthy uncle (the defendant, Mr Brown), who lived in Epping Forest.

This was the cost of the executed man's funeral which Mr Cook had paid. Mr Cook explained that in January 1792 Middleton had been sentenced to be transported for seven years for highway robbery. That crime was committed on 29 December 1791 and his victim was Thomas Bromwell, the nine year old apprentice of bed-lace and fringe manufacturer Joseph Hutton. Thomas had collected two and a half pounds of white cotton twist valued at 2s 9d, nine ounces of cotton yarn valued at 4d, two ounces of mixed-coloured cotton twist valued at 6d, one pound of white twist valued at 1s, three wooden bobbins worth 1d, all of which he was carrying in a canvas bag worth tuppence. The material was to be made up by his master.

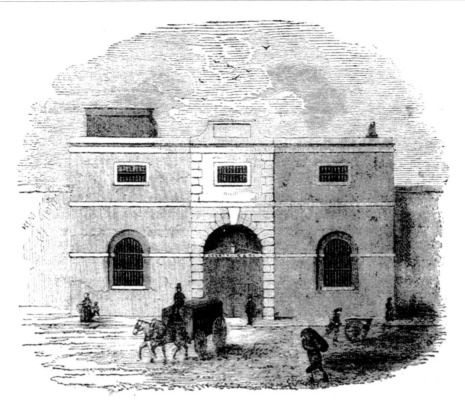

The newly constructed County Gaol on Horsemonger Lane. (*Author's Collection*)

Middleton approached Thomas and pulled the boy's hat down over his eyes before grabbing the canvas bag and running off. Alerted by the youngster's cries, Samuel Jones, a watchman, detained him at a place known as Break Neck Steps. Middleton had by then dropped the bag and its contents to the ground, and these were retrieved by Thomas outside the shop of brush maker Mr Ashmore on Snow Hill. Middleton was convicted on the boy's identification evidence but he was not sent overseas and served seven years hard labour in the hulks at Woolwich.

Mr Cook claimed that on his release Middleton approached Mr Brown for assistance, but he did not wish his friends and business associates to know he was related to such a notorious criminal. Mr Brown therefore asked the plaintiff to allow the newly released man to stay with him until a position could be found that would enable Middleton to support himself and avoid further offending.

He had remained in the Cooks' home for three months but had been unable to resist the lure of his former associates and criminal life style, to which he returned and which would lead to his being hanged. Mr Cook had borne the full expense of providing the executed man with a decent funeral and insisted the defendant had reneged on a promise to recompense him.

Mr Brown denied the allegations, claiming that Middleton had lived with him prior to being sent to the hulks in 1792 but had been ejected from his home after stealing

a number of valuable items. Since then he had had no contact with Middleton, who although a relative of his wife's, was in fact more closely related to Mrs Cook. This, he believed had placed more responsibility on the Cooks to help Middleton when he was alive and to pay the funeral expenses after his execution. The Cooks did persuade Mr Brown to contribute two guineas towards the cost of the funeral, but he refused to pay any more money. Mr Brown brought several witnesses to support his account but the jury found for the plaintiff and directed that he should pay £12 6s 4d to Mr Cook.

John Hale and David Trimmer, who had been convicted of separate burglaries, were hanged on 25 August. Trimmer had a lengthy criminal history and died a penitent man.

1801

On 6 April, another multiple execution saw five men standing on the scaffold. Thomas Hazard (alias Durham) and John Sims had both been convicted of highway robbery, William Brown (who was also known as Cousens) of burglary and Joseph Carvill of stealing fifty-eight sheep at Cuddington. The fifth man was thief James Day. He was arrested while breaking into a dwelling on Rose Street, Covent Garden, after which his house was searched. Four rolls of calico were found and these were part of the proceeds of a raid on the grounds of calico printer Mr Sutherland, on 15 March. It was for this offence that Day was hanged.

On 17 August housebreaker Thomas Southby, coiner Charles Watson, and John White who had committed a burglary, were hanged alongside William Harrison, a convicted rapist.

Harrison was one of a number of soldiers serving with the 18th Light Dragoons, then based at Guildford, who had been tried for committing a burglary at the Black Lion in Kingston, during which a servant, Sarah Berry, was raped. His comrade, William Stedman had also been convicted of the rape, but after the trial Harrison confessed that Stedman had not been present when the crimes were committed. Harrison's statement was taken down by the Reverend William Winkworth, chaplain at the New Gaol, part of which read;

> That himself together with Corporals Palmer, Cline and Faris and a private of the name of Ware were the only persons concerned in the crimes of which he and William Stedman were convicted. That himself first and afterwards Palmer and Cline severally had carnal knowledge of Sarah Berry and no other. That he and Stedman were drinking in the house where the prosecutrix lived, the night before, which circumstance he believed induced her to swear to them more than any recollection she had of them at the time of the offence.

Faris had fled but a number of statements corroborating that of Harrison's were taken from participants in the crimes and other witnesses, including confessions made by Richard Palmer and James Cline. Stedman was pardoned and Harrison was the only man executed for the crimes.

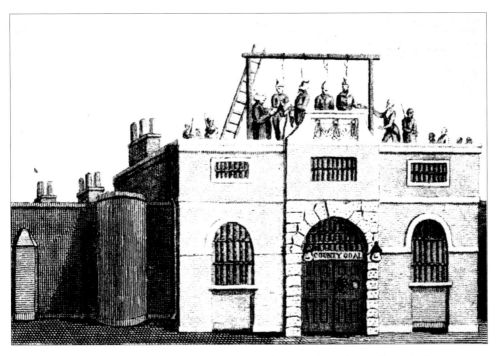

Executions on the roof of the gaol were seen regularly in Southwark. (*Author's Collection*)

1803

A Special Commission was held at which Edward Despard a fifty year old army colonel, John Francis an army private aged twenty-three, John Wood also an army private and aged thirty-three, Thomas Broughton a carpenter aged twenty-six, thirty-five year old shoemaker James Wratton, John McNamara a carpenter aged fifty and fifty-three year old slater Arthur Graham were convicted of high treason and were executed on 21 February.

In passing sentence, Lord Ellenborough told them they were to be drawn to the place of execution in hurdles, where they would be hanged, but not until they were dead. Whilst still conscious they would be cut down and their bowels torn from their bodies and burnt before their eyes. They were then to be decapitated and their bodies cut into quarters. Three other men, Thomas Newman, Daniel Tyndale and William Lander were also convicted but were later reprieved.

The government had suspected Irish born Colonel Despard, a former administrator in the Caribbean and Central America, of supporting the movement for Irish independence. In 1798 with the suspension of habeas corpus, he was detained for three years before being released without charge. However, he felt a great sense of injustice and his bitterness was directed towards the government. His thoughts turned to revolution and he was able to persuade others that success could be achieved. On 16 November 1802 he was arrested with a number of supporters at the Oakley Arms

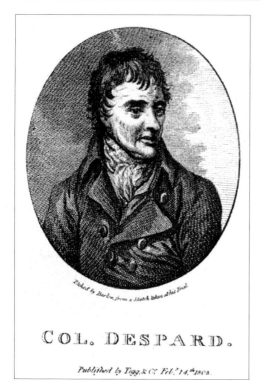

COL. DESPARD.

Published by Tegg & C: Feb.14th 1803.

Colonel Edward Despard. (*National Portrait Gallery*, London)

in Lambeth, as he was suspected of leading a conspiracy aimed at overthrowing the government and seizing power. They had been betrayed by Thomas Windsor, who was the main crown witness at their trial for high treason, which was held on 7 February 1803. Specifically, they were said to have been intending to corrupt soldiers, seize the Tower and Bank of England, and were plotting to assassinate George III. These objectives having been achieved, they hoped, rather naively, that they would have widespread popular support and would be able to seize power.

Lord Nelson appeared as a character witness for Despard during the trial, having served with him on the Spanish Main some years earlier. He described him as a loyal man and good officer, but this did not prevent Despard and the six others being convicted and sentenced to death. Despard had married a local woman while serving in Central America and after the trial his wife Catherine fought to have him pardoned, or for a reduction in the severity of his sentence. She was one of the first high-profile black women in London and despite the misdeeds of her husband, she gained a great deal of respect for the way she conducted herself and fought on his behalf. However she was only partially successful, as it was decided that the condemned men should not be quartered after being cut down from the gallows whilst still alive, but instead would simply be beheaded following their executions.

The executioner was William Brunskill, and on the morning of the executions, the condemned men were placed in a small cart, from which the wheels had been removed. With great solemnity this was dragged by two horses across the courtyard of the gaol

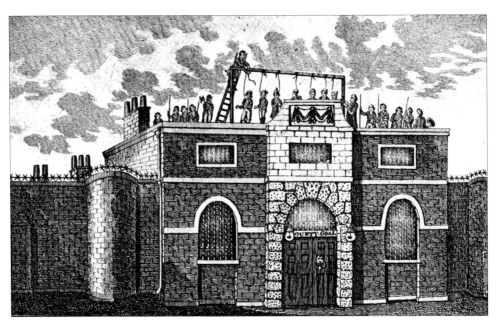

The seven traitors are hanged. (*Author's Collection*)

to the steps leading to the gallows on the roof. Colonel Despard seemed to be in good spirits as he shook hands with his solicitor, and was the last to be placed in the cart. As the hangman and his assistant sat on either side of him, each carrying a cutlass, Despard reportedly exclaimed mockingly 'What nonsensical mummery'. The colonel addressed the crowd from the scaffold, proclaiming his innocence, but he was the only one to do so as the other men remained silent.

After they had been hanging at the end of the ropes for thirty minutes, a masked man appeared on the scaffold. The bodies were cut down and each was decapitated in turn, after which the head was held aloft, shown to the crowd, and the masked man shouted 'Behold the head of a traitor'.

Catherine was not finished however, and overcame the strongest possible opposition from the government to ensure that her husband was interred in St Paul's Cathedral, which was his right. On 1 March his body was taken to the cathedral by friends in a hearse and three mourning coaches and his remains interred at the north door. The bodies of his fellow conspirators were buried in a single grave in a church on London Road, St George's Fields.

*

On 31 March Stephen Stillwell was executed for the murder of his wife, Mary Ann on 28 September 1802 at the *Jolly Gardeners*, the inn the couple owned in Mortlake.

At five o'clock on the morning of the crime, neighbour John Ward was dressing for work when he heard raised voices coming from the inn. He recognised that of the

landlord shouting 'Come, get up, your time is expired'. This was followed by a scream after which he heard Mrs Stillwell pleading 'My dear Mr Stillwell, don't murder me'. There was the sound of repeated stamping after which Stillwell emerged into the street covered with blood exclaiming 'I have my liberty' and looking towards the inn continued by shouting 'Damn that house, set it on fire'. He ran away but with the help of passers-by, Ward detained him and summoned the local constable, who found that Mrs Stillwell had been beaten to death. At his trial, Stillwell's barrister called a friend of the accused, Mr Brown, who described a recent history of strange behaviour, which had led him to believe he was insane. When asked by the same friend on one occasion to have a pint of porter, Stillwell refused saying he did not want to go into the inn saying his wife made him miserable. The judge advised the jury that it was clear that the marriage was failing and it was for them to decide if the prisoner was insane, but the judge was not convinced by the evidence given. The jury agreed and convicted him of murder and having sentenced him to death, the judge directed that he was to be dissected afterwards.

<div align="center">*</div>

Seven men were hanged on 4 April and these were burglars Joseph Rose, James Kelly and William Stephens, together with George Wilbraham who had been found guilty of horse theft and footpad John Fisher. The other two who were executed that day were arsonists Charles Connel and William Lyons who had been found guilty of maliciously and wilfully setting fire to the barn of Thomas Morris at Mersham on Saturday 29 August 1802.

Brothers John and Charles Connel and their friend William Lyons were hired by farmer Thomas Morris to help with the wheat harvest. However, he dismissed them as he was unhappy with their work and instead of paying them the agreed 18s per acre of wheat gathered, he paid them only 15s when they met at the *Fox Inn* to receive the wages they were owed. The men were angry and witnesses heard Lyons shout 'You use us very ill in not letting us finish the field, but you will surely repent it'.

Later, Thomas saw Lyons and Charles Connel walking in the direction of his barn and after a few minutes his son rushed into the house saying the barn was on fire. There was nothing that could be done and it was destroyed within minutes. Inside the barn, thirty six sheaves of wheat, a hay rick and nine loads of loose straw were destroyed, and four horses were burnt to death; four others were saved but were badly burnt and their recovery cost Thomas a great deal of money.

The three men were arrested and stood trial at which they pleaded not guilty and asked the jury to consider whether they would have been foolish enough to commit such a crime in daylight. John

Connel was found not guilty but his companions were convicted for their act of revenge.

<div align="center">*</div>

On 22 August four men were hanged; William Hart for highway robbery at Wimbledon on 16 July, and Thomas Fisher, Robert Allen, and Matthew Wilkinson, all of whom were convicted of stealing from a ship on the River Thames.

On the evening he committed the crime, Hart emerged out of the darkness at the gates to the residence of a Mr Rucker and demanded that a passing chaise should stop. One of Mr Rucker's servants, however, raised the alarm and Hart rode off. The servant gave chase down Roehampton Lane where he was joined by the groom of local resident, Mr Goldsmidt. The two servants eventually cornered the man, who threatened them with his pistol. Nevertheless, they managed to take hold of the weapon and detain him until officers from Bow Street arrived to arrest him. He told his captors that his usual occupation was that of smuggler and there was thus little surprise when he failed to receive mercy following his conviction.

Fisher, Allen and Wilkinson stole a bale of cotton valued at £25 and a cask of yellow ochre worth 30s, the property of William Young and William Lightley. They were arrested at the scene but put up much resistance, Fisher being the most violent. He struck one of the officers, (John Robinson) with an oar, causing him serious injuries. Following their trial, Fisher's parents, who lived in Bermondsey, organised a petition seeking a reprieve, arguing that he was a young man of previous good character, who had come under the influence of his two more criminally experienced accomplices. They asked that their son be spared and allowed to serve in the Royal Navy.

However, the sentencing judge, John Heath, was not sympathetic and when his views were sought he wrote;

> The apparent necessity of restraining the depredations of these Fresh Water Pirates, especially when accompanied with Resistance induced me to leave all the Prisoners for execution and on perusal of the Petition, I can see no good reason for altering my opinion.

The petition was unsuccessful and the sentences were allowed to stand.

1804

Just two offenders were executed this year at a double hanging on 2 April. David Rose, a German Dragoon, for bestiality at Guildford and Hugh Evans for maliciously cutting Elizabeth Palmer at Southwark on 20 December 1803.

Elizabeth lived on Tooley Street and was a near neighbour of Evans, who was employed as a waterman. On the night of the crime she sent her servant girl to buy some beer. The youngster arrived back at the house, in a highly distressed state, her face covered in blood. She told her mistress she had been beaten by Evans for no apparent reason. Elizabeth was enraged and when she opened her door with the intention of confronting him, Evans was standing nearby. She later acknowledged using obscene language and referring to him as 'a dirty villain'. Evans immediately attacked her and knocked her to the ground saying 'Damn you Miss Palmer, I'll spoil your pretty face

for you'. He took out a knife and holding her down, cut the side of her head, her face, her neck and across the forehead.

As she gave her evidence at the trial, Elizabeth showed the deep and permanent scars to her face and there was clearly little sympathy for his defence which suggested that he had been attacked first by his victim and several of her friends.

1806

Two men and one woman were hanged on 8 April, coiners Benjamin and Sarah Herring and murderer Richard Patch.

Benjamin Herring and his wife Sarah had long been suspected of producing counterfeit coins in their house at 9 St George's Fields in Southwark. Their premises were eventually raided on 11 December 1805 by a number of officers, among them Robert Hale and William Collingbourne, both of whom testified at the couple's trial. They described finding implements and materials needed for coining together with seventy counterfeit shillings, several dollars, half-crowns and a large number of sixpences. In his defence Herring claimed to be a bird-cage maker and that all of the equipment was needed for his work. The jury deliberated for fifty minutes before rejecting this and the married couple were sentenced to death, after which the judge added that their lengthy criminal careers had come to an end, thus indicating in the strongest possible terms that they should not expect to avoid the gallows. The Herrings became the first married couple to be executed in the county, forty-three years before the Mannings, who are often wrongly said to have that distinction.

The man who stood alongside them on the gallows, Richard Patch, stood trial for the murder of Isaac Blight, before the Right Honourable Archibald MacDonald Knt., Lord Chief Baron. The case would normally have been heard at Kingston, but in view of the publicity that had surrounded this sensational crime and the fear that this might be prejudicial to the accused man, it was heard instead in the Session House at Newington.

Isaac had been living in the vicinity of Greenland Dock, where he ran his ship breaking business, which involved the purchase of old vessels and dismantling them so that the scrap could be sold at a profit. He and his wife Sarah had one live-in female servant whose brother, Richard Patch, visited her in the spring of 1803. The Blights allowed him to stay in their house and when it emerged that Patch, who had forged a friendship with Isaac, was experiencing financial difficulties at home in Devon, it was decided that he would stay in the Blight household on a more permanent basis. Born in Heavytree, Devon in 1770, Patch had attempted unsuccessfully to farm land inherited from his father who had been a smuggler, and who after completing a one year prison sentence, was recruited to act as a turnkey at Exeter Gaol.

Initially, he paid no rent to Isaac and worked for his meals and a bed. Later, it was agreed that he would receive an annual salary of £30. Eventually he found a place to live and his salary was increased to £100 per annum. Unfortunately, Isaac found himself in financial difficulties, and his creditors could not reach a mutually satisfactory

To the Kings. Most Excellent. Majesty.

The humble Petition of William Fisher and Mary his Wife of the Parish of Bermondsey Southwark in the County of Surry Lighterman.

Most Humbly Sheweth.

That Thomas Fisher their Son aged about twenty five Years was on Wednesday last Convicted at the Assizes at Croydon for the County of Surry with two others (viz) Matthew Wilkinson and Robert Allen for stealing a Bag of Cotton and one Cask of Yellow Wax the property of William Young and William Lightley. —

[remainder of petition in cursive, largely illegible]

Your Petitioners most humbly implore that Mercy [...] and that the life of their poor unfortunate Son may be saved [...] Almighty God who shall Order him hence.

And your Petitioners as in duty bound shall ever pray &c.

[signatures]
Wm Young the Prosecutor
Simon [illegible]

Above and following page: A petition for a reprieve was widely supported but this could not save Fisher. (*National Archives*)

James Burges St Johns Horslydown

Dan Wisner ... St Thomas ...

William Burgess St Johns ...

Rob Burges St Johns Horsleydown

Martha Flower St Johns Horslydown

Robt Broadwater St Johns Horsly Downs

Jane ... St John ...

Joseph Denner St Johns Horslydown

George Gardner St Johns Horsleydown

John Cord St Johns Horsleydown

Sampson Baker Gainsford Street

Joseph Cox Thomas Street

Wm Prior Gainsford Street

John Donaldson

James Donaldson

John Butler Horslydown Wharf

Timy Addis

Isbel Jackson

Fras Madox Southwark

Jn Madox Do

William Brown Gent No 23 & 24 St Georges field

Henry Lawton No 8 Prince place St Geo Do

Thomas Bull No 8 Do appraisor Do

John Kendall No 37 Fair St Horsly down

William Fisher No 2 Tooly Street

Mary Fisher

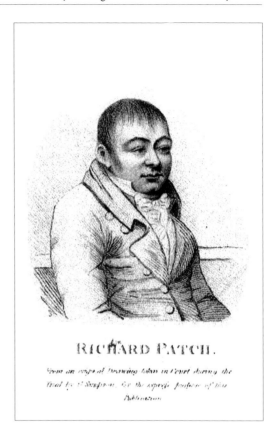

RICHARD PATCH.

From an original Drawing taken in Court during the Trial of I. Simpson, for the express purpose of this Publication.

Right: Richard Patch. (*National Portrait Gallery*, London)

Below: Mr Blight's home, where he was murdered. (*Author's Collection*)

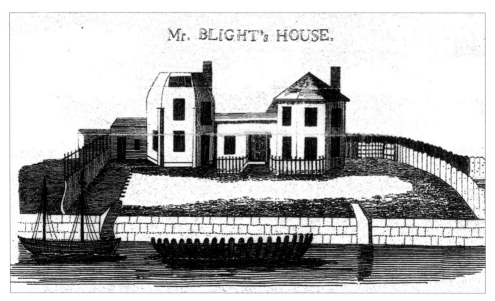

Mr. BLIGHT's HOUSE.

arrangement for him to repay the debts. This meant that he could be asked to repay all of his debts in full at very short notice. On 31 August, Isaac and Patch signed an agreement aimed at protecting Isaac from his creditors, whereby all his property was apparently transferred to Patch at a cost of £2,065.4s. Isaac would retire from the business, handing control over to Patch, who would receive one third of the profits, for which he would pay Isaac £1,250. Patch had settled his own affairs and was able to give his new business partner £250 together with a draft upon an individual named Stephen Goom, who was said to owe Patch £1,000. This was due to be repaid on 16 September, and on that day, Patch would transfer £1,000 to Isaac.

However, on the sixteenth, Patch was unable to hand the money over. He explained that there had been a temporary delay on the part of Goom, and he would receive the money a few days later, on the twentieth of the month. Isaac was becoming increasingly concerned, but clearly trusted Patch, and was persuaded to travel to Margate on the nineteenth, a trip that had been planned for some time. After Isaac and Sarah had left for the coast, Patch visited Isaac's bankers and assured them that the money would be paid in full within a few days.

On the evening of the nineteenth, Patch stayed in Isaac's home, and also there was the Blights' servant, Hester Kitchener. The two were sitting in the font parlour, which overlooked the Thames, and at eight o'clock Patch asked her to fetch him six pennyworth of oysters for his supper. Within a short time after leaving the house, Hester heard the sound of a gunshot and on her return, Patch advised her that someone had fired a gun from outside, through the parlour window. The two of them went outside and saw a number of people who would later provide important evidence at his trial.

On the following day, Patch wrote to Isaac to inform him of the incident, suggesting that as Patch had no enemies, whoever fired the shot must bear a grudge against Isaac. In the letter, he made no mention of the outstanding £1,000, which according to his wife, Isaac believed had been paid into his bank.

The Blights returned home on 23 September, and that night Isaac and Patch sat in the back parlour drinking grog. At eight o'clock Patch went into the kitchen and asked Hester for a candle and the key to the outside privy, as he said he had a queasy stomach. Within moments of his walking out of the door, Hester heard the sounds of two shots fired in rapid succession. She was horrified when Isaac staggered into the kitchen bleeding profusely, saying he had been shot and believed he was about to die. Patch rushed into the room and held Isaac in his arms, telling Hester to fetch help. Astley Cooper, a doctor, arrived and assisted by Patch and Hester, carried the wounded man upstairs to his bed.

The doctor examined him and discovered two wounds, one of which was on the right side of the body, two inches from the navel, and the second was to the groin. Both bullets had caused considerable internal damage, and there was no possibility of Isaac surviving the night. The doctor dressed the wounds and provided the dying man with opiates to ease the pain.

As he tended to his wounds, the doctor asked Isaac if he knew of anybody who might wish him harm. Isaac could think of nobody, but Patch mentioned two names. The first was that of Thomas Webster, a sawyer, who in the past Patch had accused of stealing

planks from Isaac's yard, although after a search of his premises at the time, the police found no evidence of this. Nevertheless, Patch believed Webster's son had left the area at the time of the thefts, which he considered indicated a guilty conscience and believed that his father still bore a grudge. The second man was Joseph Clarke, a labourer with whom Isaac had argued over the building of a proposed new wharf.

Isaac died soon afterwards, following which Patch produced documents supposedly confirming that he had purchased the whole of the deceased's business, and had paid Isaac in full but Sarah refuted this claim. The police also had major doubts and their enquiry focused on Patch almost from the start. It was obvious that the shots that killed Isaac had been fired from very close range and must have been from within the front garden. The police found several witnesses who had been in the immediate area when the shots were fired, including apprentice shipwright George Smith and his friend John Brown, who had not seen anybody running away from the scene. They next traced witnesses who had been present in the area on the evening of the nineteenth, and these included sisters Anna Louisa and Martha Eliza Davis, who also confirmed that they had seen nobody leaving the scene on that occasion. This led the police to believe that Patch had fired the shots on both occasions.

No gun was found, but a ramrod was discovered hidden in the privy. Furthermore, the traces of mud found on his shoes and stockings on the night of the murder, were similar to that on the banks of the Thames at low tide near to the house. The police believed that at some time in the hours following Isaac's death, Patch had thrown the gun he used to commit the murder into the river.

The men with apparent grudges against Isaac, named by Patch, were interviewed by those investigating the crime. Joseph Clarke acknowledged that he and Isaac had argued over a proposed wharf, but insisted this was several years ago and the dispute had not festered. At the time of the murder he was able to prove he had been drinking in the Red Lion and Green Dragon in Poplar. Thomas Webster had not blamed Isaac for being accused of theft from his yard and always held Patch responsible for the unfounded accusation. He provided evidence that he had been drinking in the Swallow Galley when Isaac was murdered, after which he returned home and went to bed. However, his daughter Harriet was in labour and later that night he had to give up his bed for her and she too provided an alibi for him. His son William was interviewed and he confirmed that he had not fled the area at the time of the alleged theft as alleged by Patch, but had been working in Deal.

The jury at his trial was evidently persuaded by the crown's proposition that Patch had not intended to pay £1,000 to Isaac as he did not have the money, and greed had been the motive for the crime as he intended taking over his business without having to pay him. Stephen Goom, a glue maker of Tyer's Gateway, in Bermondsey Street was traced and he confirmed he had not seen Patch for several years and certainly did not owe him any money. The draft which Patch had produced purporting to show that Goom owed him £1,000 was thus a forgery.

The police believed that Patch had fired the shot into the house when his victim was in Margate to suggest someone had a grudge against him, and had attempted to lay the blame on Thomas Webster or Joseph Clarke. The jury considered the evidence

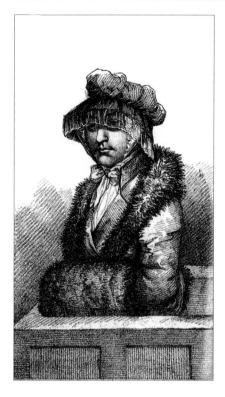

Sarah Blight testifies at the trial of Richard Patch.
(*Author's Collection*)

for ten minutes before convicting him of murder, and the judge ordered that after his execution his body was to be dissected by local surgeons.

On the morning of their executions Patch and Benjamin Herring attended the prison chapel, where they prayed with the Reverend Mr Mann; Sarah being a catholic was assisted by a priest, Reverend Griffiths. It is recorded that many thousands more than had been present for the executions of Despard and the other traitors were present to watch the three condemned meet their ends. This was inevitable given the notoriety of the murder committed by Patch, and the rare spectacle of a husband and wife being hanged together.

1807

On 23 March, John Maycock was executed for the murder of Ann Pooley on Saturday 9 August 1806. Afterwards his body was handed over to local surgeons for dissection.

When the trial opened on 20 March, standing with Maycock in the dock was his co-accused John Pope. Ann was an elderly reclusive woman who lived frugally on Free School Street, Horsley Down. Her sister Sarah had seen her for the last time towards the end of July, when she took her six Bank of England £2 notes, the dividend on the stock the sisters lived on. Her badly decomposed body was discovered on 20 August, lying on her back in the kitchen of her home, her left leg bent under her body. Her

clothes had not been disturbed except for her pockets, which had been gone through. Whoever had been responsible for the crime had made a thorough search of the house, entry to which had been gained by removing a number of bricks in the wash house wall.

Suspicion soon fell on Maycock after corn porter Thomas Griffin contacted the authorities. He had known Maycock for a few months and in June 1806 Thomas was approached by his new acquaintance who told him 'Tom, I'll put you into a good job'. He would give no specific details other than that he knew of an elderly woman in possession of a great deal of money and who lived alone. Thomas refused to participate in any such crime. In the more recent past he had met with Maycock, who had a number of £2 banknotes and when he heard of the discovery of Ann's body, Thomas reported his suspicions to the authorities. Maycock and his associate John Pope were arrested and charged with the crime.

Pope was overcome with remorse and almost immediately confessed to his part in the crime, incriminated Maycock and agreed to give evidence against him. In return he was promised a free pardon but the crown later decided to prosecute him. However, after hearing a plea on his behalf, the trial judge directed that the charge against Pope should be dropped as he had confessed after being assured that he would not be charged with any offence. He was thus entitled to be granted a free pardon and he stepped out of the dock a free man to give his testimony.

Pope told the court that he was a corn porter and had known the accused for two years. Six weeks before the murder was committed, Maycock told him of his plan to rob Ann Pooley and suggested that Pope should take part. On 9 August, Maycock proposed they make their way to her house that night. Pope agreed and it was he who gained entry to the house by removing the bricks and climbing through the hole he had created in the wall. He opened the door to Maycock, and the two men began their search of the house in the cellar. Ann had been disturbed and she came to the top of the cellar steps to investigate. Pope continued by saying that Maycock rushed up the stairs, overpowered the frail elderly woman and strangled her. The two men continued their search of the house and took gold, silver, several £2 banknotes, and some copper coins. The value of their haul was £90, which the men divided equally.

This testimony was enough to convict Maycock, who on being told by the judge that he would be dissected following his execution, replied 'Thank you for that, I'm done snug enough'.

*

On 30 March, Richard Nettlefield was hanged for an offence of cutting and maiming. Nettlefield was seen breaking into a house by watchman, John Stacey, who as he attempted to arrest him, was stabbed in the stomach, suffering almost fatal wounds. However, he made a full recovery after receiving medical treatment for a month.

The thirty-five year old condemned man was married with five children and worked as an under gardener for Joseph Alcock, who wrote to the Home Office in support of a reprieve. A petition was well supported in his home parish of Putney and was signed

by his victim. Nevertheless, the trial judge was not sympathetic and Nettlefield did not escape the scaffold.

1808

On 7 April, James Hooper, Abraham Brace and William Sadler, were hanged for involvement in a number of highway robberies in the early months of 1808.

The three men were arrested some weeks earlier with Samuel Hanson, alias Bowden, and William Shepherd, alias Knight, all of whom were suspected of being members of a gang of highway robbers and evidence was discovered linking them to two particular crimes in February.

George Taylor was returning home to Croydon from Wandsworth at seven thirty one evening, when his cart was stopped on the Common by five men. A pistol was pointed at him and he was ordered to hand over his cash and valuables. What money he had was taken together with his watch, but the robbers were not satisfied. They took two of the crates he was carrying which contained clothes belonging to his brother. George later identified Hooper as one of the men, and his sister-in-law, Mary Taylor, proved that a coat the suspect was wearing when arrested belonged to her husband and had been in one of the crates taken by the robbers.

George Goddard had spent the day at Uxbridge Market and was driving his cart home to Feltham, when at six thirty he was stopped by four men on Dawley Avenue which lay between Hillingdon and Harlington. They robbed him of his watch, some silver, his coat, a silk handkerchief and a pencil-case, but failed to find the £160 in bank notes he was carrying. He told the constables that he believed Hooper, Shepherd and Hanson had been three of the men, but evidence linking only Hooper to the robbery was found when the pencil-case was discovered in his house on Devonshire Street in Vauxhall. George's silk handkerchief was found in the possession of Sadler.

Edward Walter, a private in the First Regiment of Life Guards came forward after hearing of the arrests to say he had seen all of the prisoners in The Vine public house in Hillingdon a few hours before George Goddard had been robbed. He thought they were behaving suspiciously and had seen Hanson with a pistol. Nevertheless, there was only sufficient evidence to capitally convict Hooper, Brace and Sadler.

1809

On 4 April four men were executed; burglars John Biggs and Samuel Wood, Henry Edwards who had been convicted of highway robbery and James Bartlett, found guilty of sodomy.

The hangman later reported that as he placed the noose around the neck of Biggs, the condemned man said to him 'I wish you had a better office'. After the executions had taken place, a hearse carried the body of Bartlett to Limehouse where he was to be buried by his family. In his will he left £1,500 to his daughters.

To the Kings Most Excellent Majesty

The Humble Petition

of the under mentioned Inhabitants
of the Parish of Puttney in the
County of Surrey.

Sheweth,

That Richard Nettlefield Labourer
of this Parish was convicted at the late Assizes
for this County held at Kingston for cutting and
maiming a watchman in the discharge of his
duty and is ordered to be executed on Monday
next.

Your Petitioners humbly beg leave
to represent to your Majesty that the said
Richard Nettlefield was prosecuted by direction and
at the expence of the Parish, that he is an
active Man 35 years of Age has a wife and
five Children and a Brother a respectable
Man who has lived several years with a
Gentleman in this Neighbourhood all of whom
are in the greatest distress on account of
the unfortunate Mans situation and your

Above and following page: The petition raised by Nettlefield's neighbours.
(*National Archives*)

petitioners commiserating their Sufferings and hoping that the ends of Justice would be attained by his being transported for Life

Most humbly solicit the extension of your Majesty's Mercy so far as to prevent the full extent of the Law being carried into effect.

Putney 26 March 1807 —

Robert Hankey (Committing Magistrate)

The mark of
John + Stacey (the man maimed)

Matthew Bloxham Minister.

Richard Saunders } Churchwardens
J.? Prissman

Tyson Chapman } Overseers
William Hawes

*

James Cooper and William Moulds, who had both been convicted of murder at the Assizes held days earlier at Croydon, were executed on 16 August.

Cooper had been tried with his mother for the murder of seventy-one year old Joseph Hollis on Thursday 4 May 1809. Joseph was the owner of a cottage in the village of Compton, which he converted into two dwellings and rented to one Mary Cooper and her son James.

Joseph had been careful with money throughout his life and often carried cash, which could be in excess of £100, in three canvas bags. In one he kept notes, in another there were gold and silver coins and in the other he kept copper coins. On Wednesday 3 May he told Mary Wisdom, who called on him daily to assist with his chores and cooking, that on the following day he was travelling to Guildford Fair at which he hoped to buy a number of sheep. He would be eating his breakfast at four o'clock in the morning, and there was no need for her to call on him as he would be away from home all day.

On Friday morning, Mrs Wisdom's daughter called at Joseph's cottage and found the door open. She walked in to discover his badly beaten body on the floor and immediately contacted the police. A surgeon was also summoned and he confirmed that his skull was fractured in two places, his jaw and a finger were broken, there was extensive bruising to his arms and his throat had been cut to such an extent that his head was almost severed. The murder weapons, a knife and poker, both of which were covered with blood, were near the body.

His unfinished breakfast was on the table and on the floor were pieces of broken crockery and upturned chairs, which led the police to conclude that he was murdered as he was eating breakfast on the previous day, but only after a fierce struggle. They called on the Coopers and noticed there was an internal and unlocked communicating door between the two households and were surprised to learn that neither mother nor son had heard any noise when the murder took place. This was especially ambiguous as the walls were so thin that Joseph's ticking clock could be heard quite clearly from the Coopers' side of the wall.

When shown the murder weapons the Coopers claimed that both the poker and knife belonged to Joseph. Nevertheless, the police received confirmation from neighbours that both belonged to the Coopers. A blood stained dress which was found after a search of the Coopers' cottage strengthened the case the police were building. This received a further boost when neighbours spoke of a fierce argument Joseph had with James over unpaid rent a few days before the murder.

The Coopers were arrested and robbery was believed to be the motive. Under questioning, Mary Cooper broke down and blamed her son for the murder, claiming that she had attempted to dissuade him. However, she was put on trial, as it was believed that although she might not have been involved in the attack itself, she was nevertheless equally guilty as she had been involved in planning the crime. The jury decided otherwise and she was found not guilty and released from custody.

Moulds was convicted of the murder of William Turner, who was shot on the road near Farnham on 18 May 1809. The killer was a deserter from the 52nd Regiment

based at Winchester and was walking with two young women, Elizabeth Roper and Mary Fisher. He told them that he needed a change of clothing and money if he was to avoid arrest and added that he was prepared to kill to obtain them. They met William Turner who was walking to Farnham, where he promised his new acquaintances could sleep in his brother's barn that night. Later, as William walked a little ahead, Moulds shot him in the back with his musket. However, the wounded man had enough strength to flee and make his way to the house of Mr Bolt, a surgeon. He was able to describe his attacker, and a party of soldiers was sent in search of him. Moulds was captured soon afterwards and was taken to the bedside of his victim, who identified the prisoner as the man who shot him. This, together with the evidence provided by Elizabeth and Mary, was enough to ensure his conviction of wilful murder as William died two days after being shot.

*

Five days later on 21 August, George Donohough was hanged for rape at Southwark on 17 May.

Donohough was a fifty-one year old labourer in the building trade and was regular visitor to a public house in St George's Fields. The landlord and his wife had a ten year old daughter, Susan Rice. On the night of the crime, Donohough lured the girl into a secluded part of the premises, where he raped her. Afterwards, he threatened her with death if she told anyone what had happened. However, the following day she became so unwell that a doctor had to be called and the events of the previous evening came to light and Susan named Donohough as her attacker. He denied the crime but Susan gave her evidence in a moving and confident manner and Donohough was hanged in front of a large crowd of spectators who made their feelings of disgust at what he had done, clear to the condemned man immediately he appeared on the roof of the gaol.

1810

On 13 April, horse thieves John Gosden and William Simmonds were executed with William Batchelor, convicted of sheep theft.

*

Eighteen year old Richard Valentine Thomas was hanged on 3 September for uttering and forgery in July 1810, having passed a cheque, knowing it to be forged. The cheque in question was for £400.8s on Messrs Smith, Payne & Smith, of George Street, Mansion House, purporting to be drawn by Messrs Diffell & Son. Thomas was the son of a respectable tradesman in the City of London, and had been placed with a wealthy barge master at Blackfriars two years earlier. However, he forged a cheque for one thousand pounds in the name of his employer and obtained the money. The crime was discovered but his employer took pity on Thomas because of his youth and

also because of the friendship with his father. A decision was therefore made not to prosecute him on condition the money was repaid.

His family arranged for Thomas to go to sea with the Royal Navy but following his first voyage, he left the ship and returned to London. He committed several forgeries before being arrested for the offence for which he was hanged. He impressed those spectators who attended his execution, for despite his youth he met his death with great firmness. He was dressed in a fashionable and gentlemanly style, wearing a blue coat with gilt buttons and which was lined with black silk, a white waistcoat, and black silk breeches and stockings. A press report also noted that 'his hair was unpowdered and his upper lip adorned with Hussar mustachios'.

1812

John Smith and William Cundel were hanged on 16 March for high treason, their crimes having been committed after they were taken prisoner by the French in 1808. They were accused of entering the service of an enemy; had worn the uniform of the enemy; had assisted the King's enemies; and had acted as guards over British prisoners being held by the enemy.

Smith, a Liverpool born carpenter, was the first to stand trial on 13 February before the Special Commission which had been set up to hear the evidence. He had been serving aboard the Royal Navy frigate *Magicienne* and it was his former shipmate, John Groves, who provided the most damning testimony.

The ship was ordered to sail to the seas surrounding the Isle of France (modern-day Mauritius) and John described several conversations he had with Smith during the voyage, in which the accused repeatedly said that he hoped the French would capture their vessel and that the crew would be taken to the island's capital, Port Louis. Smith made it clear that he would have no hesitation in joining the service of the French, which he had done on a previous occasion. He explained that being in the Royal Navy was no better than slavery but when he had collaborated with his captors he had been treated like a gentleman.

In 1808, the ship ran aground as it neared the Isle of France and its captain ordered the crew to set the *Magicienne* alight to prevent it falling into the hands of the French. The members of the crew were taken as prisoners of war and John Groves was put in a boat with Smith and a French private and corporal. He testified further that he saw Smith in conversation with the corporal and after reaching the island, he was not put in the prison with the rest of the crew, but left with the corporal. Other witnesses were called who in the following months had seen Smith working in the barracks, wearing a French uniform, for which he was often heard to boast he was paid two dollars a day.

Smith denied all of the charges, claiming that those who had testified against him had simply lied. He acknowledged he had worn a French uniform on one occasion only, but that had been during an escape bid. However, the jury rejected this account and he was found guilty.

The trial of Dublin born Cundel took place on the following day. He had been serving on board the frigate *Laurel* which surrendered to the French in September

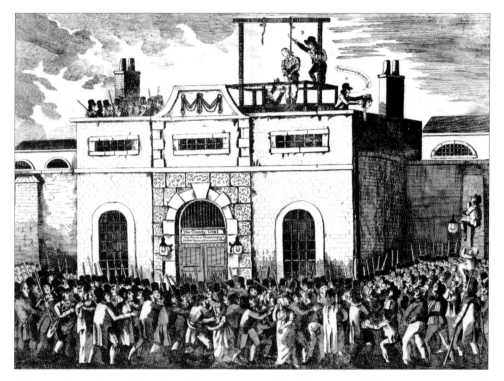

The executions of Cundel and Smith were witnessed by a large crowd of spectators. A) Smith's head is held aloft and B) Cundel's body is cut down. (*Harvard Law Library*)

1808. The crew was taken to the Isle of France and put in a sordid, vermin ridden prison in the Black River district. The prisoners had a plentiful supply of fresh water but they received only a small amount of food.

Several witnesses were called who testified that Cundel had entered the service of the French willingly. One of these was his former shipmate Joseph Watts, who confirmed that the accused man had initially been confined in the prison, but left after three weeks. He returned within days, wearing a French uniform and served as a guard over the British prisoners.

Captain Woolcomb of the *Laurel* told the Commission that following their capture, the officers had been separated from the crew and been paroled on the island. However, after eleven months they were put in the prison with the lower ranks, where they remained until the French surrendered to the British. During their imprisonment, the officers complained to the French that they objected most strongly to being guarded by those they regarded as traitors. They were removed but Captain Woolcomb testified that he often saw Cundel wearing a French uniform and seemingly taking great pleasure in ridiculing the British prisoners. The witness also told the Commission that Cundel had refused to salute British officers, but willingly saluted the French.

Cundel defended his actions by highlighting the squalid conditions in the prison but he was found guilty. However, the jury added a strong recommendation for mercy.

Several trials had taken place before those of Smith and Cundel and more were due to be heard before the Commission concluded its business. After the surrender of the French it was agreed that any British service men who had assisted the enemy could leave the island and return to France and thus avoid any repercussions in England. Almost forty men took advantage of this agreement but twelve decided to hand themselves over to the British. They were aware they faced the possibility of being treated as traitors but they hoped for leniency. However, the twelve men were charged and the Special Commission was set up to hear all of those cases. Prior to the trials of Smith and Cundel, five others had been convicted and these were Cornelius Parker, John Tweedle, John Quigley, George Armstrong and Samuel McFarlane.

Such was the importance with which the Commission was viewed that the Attorney General himself had conducted the prosecution for the Crown and following the conviction of Cundel, he made a surprise pronouncement. In an emotional speech, in which he cried openly, the nation's senior law officer stated that it had been decided not to continue with the trials. The hearings had been of immense importance as they had sent a message to those serving in the navy and military, that if they had the misfortune to fall into the hands of an enemy they could not serve that enemy to avoid temporary difficulties. He was now of the opinion that the seven convictions were sufficient to serve as an example.

The Lord Chief Baron agreed with this decision and ordered those already convicted should be brought before him to be sentenced. He told them that from the start of the war with France, there had not been one session of Parliament in which the thanks of both houses had not been repeatedly given for the brilliant actions of the nation's sailors across the globe and he lamented the fact that so many had betrayed their country on the Isle of France. He concluded by sentencing the seven men to be hanged but not until they were dead; they were to be cut down whilst still alive and their bowels be taken out and burnt before their eyes; then be decapitated; and afterwards their bodies be cut into quarters.

Five of the condemned were pardoned and only Smith and Cundel were executed. However, they were not disembowelled and their heads were only cut off after they were dead. Several thousand spectators watched their executions and were largely sympathetic as there was a widely held view that the fact that they had been selected to serve as examples when others, guilty of similar crimes had been pardoned, was contrary to the principles of natural justice.

*

Brothers Thomas and Adam Lee were executed on 13 April for the crime of highway robbery. They, together with Thomas's wife Eleanor, were tried for robbing Elizabeth Collier on the road between Horsham and Walton on 21 October 1811.

Their victim was a servant in the household of Mr & Mrs Giles, who had sent her on an errand to Walton, and it was on her return journey that the crime was committed. The three Lees approached her and Eleanor asked if she wished to have her fortune told, an offer Elizabeth turned down.

Without any warning, Thomas grabbed her by the neck and with the help of his brother dragged Elizabeth through a fence and into a field not visible from the highway. Eleanor continued to take an active part by kicking her repeatedly about the body. The beating continued until Elizabeth passed out. When she came round, she found she had been stripped of her gown and petticoat and was almost naked. She screamed but was told to be quiet or she would be murdered if she continued to call out. The attackers eventually left her but not before robbing her of all her money.

Elizabeth was able to give full descriptions of her attackers who were arrested the following day. At their trial they pleaded not guilty and several witnesses were called who provided alibi evidence, claiming the three accused were elsewhere at the time of the robbery. Nevertheless, they were convicted and Eleanor was sentenced to be transported for life. After the trial, she and her husband were allowed a few moments together to say their farewells before being placed in separate cells; both were distraught as he kissed her and their five week old baby, which she held in her arms.

*

On 10 August, Daniel Davis was executed for selling forged bank notes in the early months of the year in Southwark.

In the late spring and early summer of 1812, a number of people were arrested for using forged Bank of England notes. After the culprits were questioned, it became clear to the authorities that Daniel Davis, landlord of the Crown public house in Southwark, was the individual who was supplying the notes and was using the pub as his base. A plan was devised to catch him in the act of selling forgeries to ensure his conviction at trial.

John Castle, a prisoner being held in Clerkenwell Gaol, was known to have bought forged notes from Davis in the past and in return for a reduced sentence, he agreed to help. He was provided with genuine notes which had been secretly marked by Bank of England officials and he was searched to prove that he had no forgeries on his person. He visited Davis at the Crown, where he purchased several forgeries having handed over the genuine notes. The two men were immediately pounced on by a number of waiting constables. Davis was searched and the genuine but marked notes were found on him. Castle had the forgeries in his pocket, proving that a criminal transaction had taken place. Furthermore, Castle pointed to the landlord's favourite chair in which a large number of forged notes were discovered, ensuring Davis would stand on the gallows.

1813

On 5 April Sarah Fletcher was hanged for murdering her bastard child at Wandsworth.

The child's body was discovered in a privy and his nineteen year old mother had used a garter to strangle him. A crowd of many thousands assembled to watch the execution and were impressed by her bravery. She wore an elegant black silk dress for the occasion.

*

A few days later on 13 April, five men were hanged simultaneously, all of whom had been convicted at the recent Kingston Assizes. Thomas Bogginton had been found guilty of burglary at the home of Theodore William Hill at Bermondsey and stealing several items including a watch. Thomas Francis had also been similarly convicted of breaking into a house at Warlingham and taking valuables, which included a silver watch.

*

Thomas Norman was alone convicted of breaking into the shop of draper Peter Davis, which was situated close to Westminster Bridge, on the night of 30 October 1812, and taking a quantity of sewing silk, silver coins and banknotes valued at more than £200. Norman was believed to have been a member of a violent gang of burglars who had committed a number of crimes in Surrey and beyond. The main witness against him was Joel Ware, a fellow gang member who in return for a pardon agreed to testify for the crown. He told the court that some days before breaking into the premises Norman had visited the shop where he bought a waistcoat, which he would be wearing later when arrested, and had taken the opportunity of studying the layout. Another gang member named Harrison, who was not before the court, had also called at the shop and asked to be measured for a suit, thus taking the opportunity of making another assessment of the building. The crime was committed by Norman, Harrison and Ware who gained entry through a cellar window. Once inside, the intruders ransacked the shop before returning to Ware's house in Artillery Place where the money was shared out, and later the silk was disposed of by a receiver named Simmons.

Norman had also been convicted with William Moss (alias Hassledon) of another burglary at the Streatham home of wealthy William Wilkinson, and Joel Ware was the leading crown witness at this trial also. Mr Wilkinson was disturbed by his barking dog in the early hours of 7 November 1812 and, on going downstairs to investigate, he discovered the burglars had gained entry through a window in the back parlour. A bureau and cupboard had been forced open from which several gold coins, two silver cups and a silver watch were missing. Ware testified that he had taken part in the crime with the two accused and had been told by one of William's disgruntled former servants the best way of gaining entry to the house and where the valuables were kept. The cash was shared out and the silverware was again disposed of by the receiver, Simmons.

*

Luke Martin was tried together with his co-defendants, married couple James and Mary Ann Wright for high treason, namely counterfeiting silver coins. Their apartments were raided after the police were tipped off by an informant, and in Martin's they discovered a die with the head of Queen Anne. The Wrights were found to be in possession of

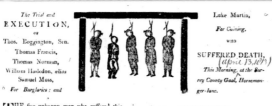

The broadside text:

The Trial and
EXECUTION,
of
Thos. Boggington, Sen.
Thomas Francis,
Thomas Norman,
William Hasledon, *alias*
Samuel Moss,
For Burglaries ; and

Luke Martin,

For Coining.

WHO

SUFFERED DEATH,
(April 13, 1813)
This Morning, at the Sur-
rey County Gaol, Horsemon-
ger-lane.

THE five unhappy men who suffered this morning the awful sentence of the law were capitally convicted at the late Assizes for the County of Surrey, held at Kingston-upon-Thames. Their crimes were as follow :—

THOMAS BOGGINTON, Sen.

was convicted of burglariously breaking and entering the dwelling-house of Theodore William Hill, at Bermondsey, and stealing therein, a metal watch, and other articles.—Guilty, Death.

THOMAS FRANCIS

was charged with breaking and entering a dwelling house, at Warlingham, and stealing a silver watch, and other articles.—Guilty, Death.

THOMAS NORMAN

was indicted for burglariously breaking and entering the house of Peter Davis, and stealing a quantity of sewing-silk, and other articles, his property, to the value of 200l. and upwards.—The Jury found the prisoner Guilty.
Thomas Norman was indicted together with

WILLIAM HASLEDON,
alias SAMUEL MOSS,

for another burglary in the house of William Wilkinson at Streatham, in Surrey.
Mr. Wilkinson, who is a gentleman of fortune, residing at Streatham, proved that on the 7th of November last, he was alarmed in the middle of the night by the barking of his dog, he got up and went down stairs, when he found the house had been broken open, through a back-parlour window, as a part of the shutter was lying upon the lawn ; they had also broken open a bureau, in which were several gold coins, and a cupboard, containing the plate. Among the plate were two silver cups, and a silver watch, gilt. He supposed they had escaped at the noise he made in getting down stairs.
The Jury found the prisoners both Guilty, when the learned Judge immediately passed sentence of death upon them, and told them they must expect no mercy, but prepare to meet their awful fate.

Printed by Jennings, 13, Water-lane, Fleet-street, London

LUKE MARTIN,

was tried together with James Wright, and Mary Ann Wright, upon an indictment for high treason in counterfeiting the silver coin of the realm.

Hutt, an officer of the police, stated that he and some other officers, having received information, went to the house of the prisoner, in South Lambeth, expecting to find that coining was carried on there. When they got there, they first went into an apartment below, which was inhabited by persons whose names they did not know ; but they found nothing suspicious there ; they then went up stairs to the apartments inhabited by James Wright and his wife (who were tried with Martin) and finding that some persons were in the room, they burst in ; there they found aquafortis on the mantle-shelf, a vice, several round blanks resembling shillings, and all the apparatus necessary for the making of base money. In addition to these they found a die with Queen Anne's head, and a counterfeit shilling, evidently the produce of that die. In Martin's apartments they found a fly-press, and several other coining implements.

Wright said that he had been but ten days in the house, and that one Golding had left these articles in his room, he believed, for the purpose of informing against him.

The Jury, after considerable hesitation, found Martin guilty, Wright guilty, and the Wife not guilty ; but recommended Wright to mercy.—The learned Judge immediately passed sentence, and told Martin to expect no mercy ; but Wright he should recommend to the Crown as a fit object of mercy.

This morning the before-mentioned criminals were executed pursuant to their sentence, on the top of the Surrey County Gaol, Horsemonger-Lane. They all apparently behaved themselves in a manner becoming their awful situation. We trust that the melancholy exhibition itself, and the relation of it contained in this paper, will have the effect of deterring others from the transgression of the Law.

PRICE ONE PENNY.

A broadside gives details of the crimes committed by the five condemned men. (*Harvard Law Library*)

aquafortis, a vice, a number of shilling-sized blank pieces of metal and one counterfeit shilling. The Wrights insisted that they had only been living in their new home for ten days and the previous owner, a man named Golding, had left the suspect items there, presumably with the intention of informing on them. Mary Ann was acquitted and although her husband was convicted and sentenced to death with Martin, he was later reprieved.

1814

Charles Callaghan was to become the only person to be executed this year when he was hanged on 2 April and his body afterwards given for dissection, for the murder of Moses Merry during the night of 16/17 December 1813 at Vauxhall.

Thirty-seven year old Moses was the butler of the wealthy Misses Gompertz, both of whom were awoken on the night in question by gunshots which appeared to be coming from downstairs. When investigated, the body of Moses was discovered and several pieces of silver had been taken from the house.

A few days, later nineteen year old Callaghan and his similarly aged companion Hylam Parish, were arrested after being discovered with the proceeds of a burglary at Chatham. Parish offered to turn King's evidence in the hope of a pardon and this was accepted by the authorities when it became clear that he could help solve the murder of Moses Merry.

The informer had met Callaghan in the recent past and they had shared lodgings on London Road. Callaghan suggested the Vauxhall burglary when their money ran out as he had worked in the household as a footman in the past. Callaghan is said to have armed himself and the pair waited outside until all of the house lights had been extinguished. They gained entry by removing the shutter to the kitchen window before cutting out a pane of glass. They pocketed six silver tea spoons and a pair of sugar tongs. They next opened the pantry door and were astonished to see the sleeping butler so withdrew quietly, hoping not to disturb him. However, Callaghan, who had worked with the butler, recalled that Moses possessed a valuable silver watch, which he hung over the head of the bed at night. He instructed Parish to go back and look for it, thinking that Moses would have it with him in the pantry. However, in doing so, Parish woke Moses up.

Alarmed, Moses jumped out of bed and ran into the kitchen. Callaghan realised that Moses would recognise him and shouted to Parish "Give it to him Bill". Parish insisted that he refused to shoot at the butler and Callaghan put the muzzle of the pistol to the terrified man's temple and shot him in the head.

1815

John Anderson guilty of highway robbery and William Woodham (alias Jennings), convicted of sheep theft, were executed on 17 April.

Anderson was tried at the Old Bailey for a highway robbery at Staines and another in Surrey. Woodham, was convicted of stealing sixteen sheep belonging to Henry Lindup at Cuddington.

1816

On 8 April, Richard Russell became the first of two men to hang in nineteenth century Surrey for parricide, having been convicted of murdering his father at Thames Ditton on Thursday 26 October 1815.

On the morning of 27 October 1815, neighbours of the murdered man had become concerned when blood stains were seen on the front doorstep of his house. Thomas Carter forced his way in and found the elderly man's badly beaten body on the floor of his bedroom. The blood stained hammer used to inflict the injuries lay close to the body. His throat had also been cut but there was no sign of a knife. His son John told police his father kept his money in a tin box which a few days earlier had contained more than twenty pounds. This was found to be empty and robbery was thought to be the motive for the crime.

Several witnesses had seen the deceased with Richard, another of his sons, on the previous evening. The police were therefore keen to interview him and he was apprehended two days later but denied all knowledge of the crime. However, on 30 October he confessed to Joseph Walker, the keeper of Kingston House of Correction where he was being held as he awaited his trial, giving him a full account of what happened.

On the late afternoon of the crime, he met his father who was returning from Esher where he had been drinking. He invited his son to join him for a drink after he had gone home to get more cash. Once inside the house, his father unlocked the tin box and in a spontaneous act, his son picked up the hammer which was in the bedroom and struck his father several savage blows to the head. He stumbled to the floor but was not dead as he continued to groan. His killer took a knife from his pocket and cut his throat. He took two £10 notes, £2, 7 gold guineas and 1 half guinea.

He walked to the Coach and Horses in Kingston and threw the knife away on his way there. He paid for half a pint of rum with one of the stolen notes before taking a chair to the Elephant and Castle as he had missed the last coach to the city. The next morning, Thomas Hampton the landlord of the Coach and Horses heard of the murder and immediately thought of the stranger from the previous evening. He examined the note which he now noticed had blood on it. He was later able to identify Richard as the man who had passed it over the bar and the note was an important piece of evidence at the trial.

After arriving in London, the killer had made his way to Greenwich where his fiancée lodged and he spent the night with her. The following morning he called at the Torbay Inn at Greenwich where he had been lodging for seven weeks. He settled his bill of £7 12s which he paid with a £10 note. This surprised his landlord, Christian Neville as his lodger had always seemed to be short of money, but he explained his uncle had loaned him some cash. He next paid one guinea for a ring and married his sweetheart later that day. However they were destined to spend little time together as man and wife for he was arrested soon afterwards.

He pleaded not guilty but the evidence against him was overwhelming and in sentencing him to death the judge told him he would afterwards be anatomised. As he left the dock Russell was heard to say 'It is a hard thing I should die innocent'.

*

On 22 April, John Hammond was hanged for shooting at and attempting to murder farmer George Coldham Knight on the Farnham road on 28 December 1815.

At nine o'clock on the night of the crime, the victim, a wealthy farmer, was riding home to Farnham when he spotted three men on foot, ahead of him. He heard one of them shout to his companions 'Take hold, take hold' and he heard a different voice ordering him to stop. Realising he was in danger he rode on without stopping and as he did so a single shot was fired at him. However, it missed and he was uninjured but his horse was so startled it came to an abrupt halt. George looked back and saw the three men running away from the scene and he made his way home.

He offered one thousand guineas reward but nothing was heard of his attackers for several weeks. That was until George Whiting, a notorious offender, was arrested and faced being charged with a number of capital offences. To save himself he offered information relating to the attack on the wealthy farmer, which was accepted by the authorities.

The informant told of calling at the house of John Hammond and finding James Ratford there also. Each of them had a loaded gun and told Whiting they were going out intending to commit a robbery. He joined them and it was not long before they saw George Knight approaching. After attempting unsuccessfully to force him to stop, he insisted that he was astonished when Hammond fired at the fleeing farmer. The three of them ran to a field and Whiting insisted he told Hammond 'I cannot think how you could come to have fired the gun', to which he replied 'Because I meant to have had him'. He knew he would have murdered him and Ratford too was aware of this as he too remonstrated with Hammond over the shooting.

Hammond and Ratford were tracked down and arrested and both stood trial charged with attempted murder. A man named Cranham testified that he had provided the pistol to Hammond and the defence barristers argued that those who had spoken against their clients were all notorious offenders determined to save their own skins. Their evidence could not be relied upon and both accused should be found not guilty. They were partially successful as Ratford was acquitted. Hammond was convicted and sentenced to death but given the strong recommendation by the jury that he should be shown mercy, it was anticipated, wrongly, that his life would be spared.

*

Two men were executed on 2 September; arsonist James Andrews, convicted of wilfully and maliciously setting fire to a warehouse belonging to George Marshall, at Godalming on 5 November 1815 and William Sims, guilty of forging a bill for £50 in February 1816 and defrauding Robert Rich.

George Marshall was a timber merchant whose wharf and warehouse were situated on the River Wey at Godalming. On 4 November 1815 he had taken delivery of a large supply of wood which he stored in his warehouse. At a little after midnight he was told that the building was alight and he arrived in time to see the roof collapse. Within minutes, the warehouse and its contents had been destroyed and an inspection the following day revealed that the fire had been set deliberately. However, there was no evidence pointing to the culprit as nobody appeared to bear a grudge against George and the investigation made no progress.

That was until several months later, when following a night of heavy drinking in Guildford, Andrews told his lifelong friend, Thomas Barringer, that he had started the fire. Barringer reported this to the police which led to the arrest of Andrews. When Thomas appeared at a preliminary hearing he acknowledged that he had reported his friend in the hope of receiving a reward, at which Andrews screamed at him 'You are a rascal! I trusted my whole soul to you and you have betrayed me'. At the subsequent trial, Constable James Voyce testified that following his arrest, the prisoner had made

a full confession. When asked why he had started the fire he replied that it was an act of revenge. The timber merchant's father also George Marshall, had been responsible for Andrews being dismissed from his job as lock keeper on the Godalming Navigation and the older Marshall's wife had later evicted the accused man's mother from her cottage.

The other condemned man was William Sims, who in the previous February had taken lodgings with Mr Lipscombe in Water Lane, Blackfriars. He passed himself off as a Captain Jones of the *Mary Ann* which was making its way to London up the Thames. He advised his landlord that his ship would require a new set of rigging and asked if he could recommend a rope maker in the district. Mr Lipscombe spoke highly of Robert Rich whose business was in Bermondsey and the captain visited those premises shortly afterwards. He declared himself happy with Robert's products and placed an order valued at £100, but as he would be paying cash he expected a discount and this was agreed to.

The captain asked a favour of Robert, saying he had no cash until his ship arrived in a few days and asked for a loan. After asking some questions, Robert was satisfied he was talking to an honest man and handed over £45 in cash. In return the captain gave him a bill for £50 drawn by John Jones and accepted by Richard Jones of 87 Duke Street, Deal, who was said to be the captain's brother.

Robert paid the bill into Williams & Co who passed it on to Messrs Lubbock & Co, agents for the Deal Bank. It was declared a forgery and a search for the culprit began but there was no trace of him until June when he was arrested in Woolwich. There, he had passed himself as Captain Jones to a barber, Mr Nichols who he was attempting to defraud of a large amount of money. However, he had heard a seafaring man call him by his correct name, Sims and arranged for him to be arrested. Robert Rich was contacted and he identified him as the man who passed the forged bill to him.

As he was being sentenced to death he fell to his knees and begged for mercy. However, the judge told him that such crimes struck at the heart of the nation's commercial activity and it was proper that those so convicted should hang.

1817

On 21 March, Thomas Simpson and Edward Cook were executed, both having been convicted of forgery and uttering.

*

On 27 November 1816, Mr Green, a gentleman of independent means, decided to send £40 to his sister, Emma Fitzgerald, who lived in Southampton. He sent a servant to arrange for a bank post bill to be prepared at his own bank giving details of the amount to be paid and the name of the payee. This was then to be signed by Mr Green and sent to Emma who would sign the document at her bank in Southampton, where she would be paid the cash. The servant left the necessary details and arranged to

return to collect the document thirty minutes later, but when he did so he discovered that someone else had collected the bill a few minutes earlier.

Later that same day, a man giving the name George Fitzgerald, called at the shop of furniture dealer, Alexander Alexander on Blackfriars Road and asked to purchase furniture to the value of forty pounds, offering the bank post bill in payment. However, Mr Alexander could not accept it as it had not yet been signed by Emma. The customer took the bill and returned a few minutes later, the document now apparently bearing the necessary signature. Mr Alexander was an experienced businessman and knew the document was genuine so agreed to the transaction. However, when presented at his bank it was revealed that the signatures of George and Emma Fitzgerald were forgeries and payment was refused.

The furniture had been taken in a cart driven by a lame boy, who was quickly traced by the police. He led the investigators to Thomas Simpson who was executed for forging the two signatures and uttering the document.

Edward Cook was betrayed by a criminal named Carpenter, who following his arrest for uttering, offered to turn Kings Evidence in order to save himself from the noose. Cook was described as a wholesale dealer and was thus a significant catch for the authorities. A publican, Benjamin Pritchard was sentenced to be transported for fourteen years for allowing Cook to store his equipment and other items on his premises. These included one hundred and fifty forged notes which were found concealed in the privy.

*

On 12 May 1817, Clayton paid for a meal and drinks at the Crown at Ewell, with a five pound note. The landlord had insufficient change and asked a neighbouring grocer to accept it in exchange for coins. The note seemed genuine to both men and the grocer readily agreed to help out his friend. However, it was subsequently revealed to be a forgery when handed into the grocer's bank in Reigate.

Clayton's description was circulated throughout the district and he was arrested a few days later, when another five pound note and seven one pound notes, all of which were forgeries, were found in his possession. He claimed that he was not aware that these notes and that used at the Crown a few days earlier were forgeries, claiming he had received the total amount of seventeen pounds from a horse dealer in Smithfield. However, this explanation did not save him.

On 1 August William Clayton was executed for uttering forged bank notes.

1818

On 14 August a double execution took place, not at Horsemonger Lane Gaol but at Godalming. George Chennell and William Chalcraft were hanged for the murders

of George Chennell Snr and his housekeeper Elizabeth Wilson, at Godalming on 10 November 1817.

George Chennell Snr, a sixty-one year old widower, was well known in Godalming, where he was a successful shoemaker and farmer, and where he lived with his sixty-two year old housekeeper Elizabeth Wilson. He had one son, also named George, who was in his thirties, but their relationship was strained, and although he ate many of his meals at his father's house, the younger Chennell, who was separated from his wife, rented rooms elsewhere in the village.

On the morning of Tuesday 11 November 1817, a customer called on George Snr to collect a pair of shoes he had ordered. He opened the door and was horrified to see, stretched out on the floor, the body of the housekeeper, who had suffered a deep throat wound. There were several bruises to her head and face, and her hand had almost been severed. A number of neighbours were alerted and rushed to the scene. They searched the upstairs rooms and the shoemaker's body was found in his bedroom. There were indications of a savage beating and his throat had been cut so savagely that he had almost been decapitated.

Surgeon William Parsons examined the bodies and confirmed Elizabeth had died as a result of her throat being cut, but the injuries to her body suggested that she had put up a fierce resistance. The surgeon believed her employer had died of a fractured skull before his throat was cut to finish him off. He reached this conclusion as the flow of blood from the throat wound would have been much greater had the heart still been beating when the injury was inflicted. Lying close to Elizabeth's body, a knife covered with blood and a hammer, similarly stained, were discovered, which the surgeon identified as the probable murder weapons.

The inquests into the deaths were held the following day, and the jury decided that both had been the victims of wilful murder committed by a person or persons unknown. However, the local constables already suspected the dead man's son and his friend William Chalcraft, a known criminal in his fifties, who was employed as a carman by George Snr.

John Currington was employed on the deceased's farm and started work at six-thirty on the morning the bodies were discovered. An hour later John asked Chalcraft, who had also turned up for work, to fetch him a glass of beer from inside the house. John watched as he went indoors and emerge a few minutes later with the drink. This had been before the discovery of the bodies and when he heard of them later, John found it difficult to believe that Chalcraft would not have seen Elizabeth's body on the floor, and indeed believed he would have had to have stepped over it when he entered the house, but he had said nothing.

Later that morning, before it was widely known that George Snr was dead or where his body lay, Henry Causton, a neighbour of the shoemaker, heard Chalcraft say 'My master and Bet are both murdered. Bet lies in the kitchen and the master is upstairs', which Henry believed, he could not have known without being present when the murders occurred. Henry also provided the constables with details of the hatred the younger George had for his father and the housekeeper. For a number of years, he had spoken of his father in the vilest of terms, and in the previous two months had said

repeatedly that he wished him dead. He also believed that the housekeeper had been spreading lies about him.

The constables had no difficulty in deciding when the murders occurred. The victims had last been seen alive at a little after eight on the Monday night, and both were known to be creatures of habit. George Snr was known to go to bed at nine o'clock, and Elizabeth usually sat up for another hour. His body was in his bedroom, and she was found downstairs, and near to the body was a shirt she was mending for her master's son. Confirmation of the time was provided by several witnesses who had reported hearing loud noises coming from the house within that hour, which were not thought to be suspicious at the time. Importantly, other witnesses had seen the two suspects in the company of a local petty criminal, Sarah Hurst, in the vicinity of the house, although the two men denied this and claimed they went nowhere near the house that night.

The constables unearthed a great deal of evidence implicating their chief suspects, which included the discovery of bloodstains on Chalcraft's clothing. A search of his alleged accomplice's lodgings revealed two one pound notes, on one of which bloodstains were present. They were known to be in his father's possession just a few days previously. He had received them on 4 November from Thomas Allathorp, a warehouseman in Gate Street, London, who had received them earlier from a woman named Mrs Baker, whose name he had written on them. On the morning of the day of the murders, it was known that George Jnr owed five weeks rent and had to borrow money to buy ale. However, at ten o'clock, shortly after the victims were thought to have met their deaths, he was spending freely in a local inn, and on the following day he paid his rent arrears.

Sarah Hurst had been seen close to the murder scene at about the time the killings were thought to have occurred, and when it was learnt that on the night following the crime, she had been seen inconversation with Chalcraft in the Angel Inn, the constables interviewed her at length. Her testimony was to prove hugely significant at the trial at Guilford on Wednesday 12 August 1818.

She admitted to being an accomplice but claimed not to have known of the plan to murder the two victims. At five o'clock on the evening of the murder she had met Chalcraft, who asked her to meet him later at nine. She met him as arranged, and agreed to act as a look out as the two accused men entered the house, not thinking that murders would take place. She heard a scream from inside and moments later the two men rushed out. When she asked what had happened Chalcraft replied 'We have done for them both'. Pointing to spots of blood on his sleeve, he continued 'It is the blood from them two'.

She left the two men but on the following night Chalcraft sought her out and offered her £4 to keep quiet about the previous night's events. She refused to accept the money saying she wanted nothing more to do with him. In return for her testimony she was not prosecuted. In his summing up, the judge stated that the conviction or otherwise of the men hinged on whether or not the jury believed the evidence of Sarah Hurst. They clearly did, for after asking them to consider their verdict, the jury took less than two minutes to pronounce them guilty.

In sentencing them to death, the judge commented on the fact that Chennell had murdered his father, and Chalcraft had murdered his master, two particularly heinous crimes. He therefore directed that following their executions their bodies were to be handed over to local surgeons to be dissected. Furthermore, the Surrey authorities decided, for what would prove to be the only time in the nineteenth century, to follow the ancient custom of hanging the guilty parties close to the crime scene. Chennell and Chalcraft were to be hanged in a large meadow to the north of Godalming rather than at Horsemonger Lane Gaol.

On the eve of their executions, Chalcraft's wife and some of his six children visited him as did Chennell's wife, from whom he had been separated for some time, who also brought their five year old son to see his father for the last time.

At nine on the morning of the executions, the two men were put in irons, had their hands pinioned, and the ropes they were to be hanged with were tied around their waists. They were put in a wagon and driven around Godalming and the surrounding area for two hours. Given the widespread revulsion felt towards these men, this parade and the subsequent executions were watched by many thousands. After the wagon was driven from underneath them they struggled violently for some time before the executioner took pity and pulled each of them downwards by their feet, thus bringing an end to their suffering.

They were left hanging for an hour before being cut down and handed over to two Godalming surgeons, Mr Parsons and Mr Haynes. The bodies were taken to the house in which the murders occurred and laid out in the kitchen, where they were dissected later that day. After the surgeons had finished with them the dissected bodies were left on public display and it is reported that several thousand people visited the house to view the surgeons' handiwork.

*

On 31 August burglars William Park and William Cook were hanged with William West, convicted of uttering two forged Bank of England pound notes the previous June at Barnes.

The hanging of twenty-three year old West, a man of previous good character proved to be one of the most controversial of the period. There was a widespread belief that in common with many other such offenders, the Bank of England should have offered him the opportunity of pleading guilty to the non-capital crime of possession of the forgeries, the maximum penalty for which was to be transported for fourteen years.

Some years earlier, West had worked for a maltster in Deptford, who described him as a hardworking and honest youth. It was there that West became friendly with another employee named Lansdowne, who quit his job to join the navy. In 1816, West started working for another maltster, Mr Barker of Bedford, but he was laid off in May 1817 due to lack of work. However, Mr Barker was impressed with the young man and promised to offer him another post when business improved.

In June, West met his old friend Lansdowne, who was with a young woman in Barnes. He told West that he was about to leave for Ireland and he wanted some silver

in exchange for two one pound bank notes and asked West if he would change them on his behalf. West did so at the Coach and Horses, where he also had a few drinks with friends. The young woman he had seen with Lansdowne came in and explained that the notes he had changed were forgeries and that he should leave immediately as he was in danger of being arrested.

However, it was too late as he was detained by a constable who was acting on information provided by those from whom he had obtained the silver in exchange for the forged notes. A packet containing a large quantity of other forgeries was found hidden outside the Coach and Horses, which he was suspected of having attempted to conceal. He protested that he did not know the notes were forgeries or anything of the hidden packet, which he suggested had been placed there by Lansdowne or his woman friend.

His supporters attempted to persuade the Bank of England that he was a naive young man who had been duped by others far more criminally sophisticated. However, the Bank was convinced that it was West who had hidden the packet and had thus been in possession of many more notes than the two he was charged with uttering, which was the reason the Bank's officials were determined he should hang.

1819

Robert Dean was executed on 8 April for the murder of four year old Mary Ann Albert on 16 October 1818 at St George's Fields.

Dean and Joseph Williams were old friends having been apprentice watch engravers together. Dean had also become friendly with Joseph's sister Mary Albert, the mother of the murder victim. He was a frequent visitor to Mary's home and was especially fond of little Mary Ann, who loved to play with him.

On the day of the murder, Dean arranged to meet Joseph at Mary's house and as her uncle got ready, Mary Ann sat happily on Dean's lap. The young men left but after walking a short distance, Dean made an excuse and they parted, after which he returned to Mary's house. He played with the little girl for a few minutes before asking Mary's permission to take her out to buy her an apple. Mary readily agreed but she began to grow concerned when they were absent for some considerable time. She went to look for them and had not walked far before she saw her daughter staggering towards her with blood gushing from a throat wound. A doctor was called to the scene but Mary Ann was dead within the hour.

A search was made for Dean but he could not be found. However, in the early hours of the following Tuesday morning he surrendered to Joseph Myatt at the watch house in Holborn after wandering around London unsure of what to do until deciding he must face punishment for his dreadful crime.

As he awaited trial he made a written confession, which offered some explanation albeit somewhat irrational, for the crime, which read as follows;

On Friday evening last I met a young man named Joseph Williams with who I had long been intimate, at Mrs Albert's house in Jacques-court, Thomas-street. I had long

been acquainted with a young woman named Sarah Longman, daughter of Mr L at the Grapes, Church-row, Aldgate; my affection for her was extremely great; I had for some time corresponded with her. A dispute unhappily arose; I wrote to her on the subject, expressing my regret at the unfortunate rupture, described the very great regard which I entertained for her, implored her to consent to reconciliation, and begged that she would write me an early answer. She never replied to my letter. Her father called upon me, and wished that the connexion might be discontinued. These circumstances had an indescribable effect upon my mind; I was miserably unhappy, was incapable of attending to my business, and gave myself up entirely to despair. I endeavoured to prevail upon her to renew the correspondence. I felt that I could not be happy in this world without her, and determined to leave it. Thoughts of a dreadful description entered my mind, and must have proceeded from the Devil. I felt that I should leave the world in a state of happiness if I could murder her, and determined to perpetrate the deed. I had been home from two days, business not being very brisk, and on Friday evening I called to see Williams, at Mrs Albert's. We both came out together and walked in company to the theatre. We did not go in; I told Williams that I wanted to see a gentleman in the Borough, and should go that way. We parted and I returned to Mrs Albert's. After talking in a very friendly manner with the family, I asked for a knife and they gave me a case-knife. I took an opportunity of concealing it unperceived in my pocket. I shortly went out with the child to buy her some apples, which having done, I returned to the court. A sudden thought came over my mind, that if I murdered the child, who was innocent, I should not commit so great a crime as murdering Sarah Longman, who was older, and as I imagined, has sins to answer for. In a moment I pulled the knife out of my pocket, put the child down out of my arms, held her head back and cut her little throat. In an instant I imagined that I was in the midst of flaming fire, and the court appeared to me like the entrance of hell. I ran away, not knowing where I went or what I did; I wandered about in a state of distraction until I surrendered myself up to the watch-house.

At his trial, Dean's barrister argued that such distorted reasoning was indicative of insanity and his client should thus be spared the noose. This was rejected by the members of the jury who decided he should die atop Horsemonger Lane Gaol.

*

James Poulter was hanged on 6 September after being convicted of sheep theft.

1820

There was a triple hanging on 10 April when for burglary and stealing sheep, Henry Payne was executed alongside James Woolwich also convicted of sheep theft and burglar William Cain.

1821

John Lambell and Jesse Sangwell convicted of burglary at Egham on 26 March 1821 and William Jarvis and Thomas Mayers, both convicted of uttering, were hanged on 18 April.

Elizabeth Green was an elderly and wealthy widow, who on the night of the crime lay on her deathbed in her Egham villa. At her bedside were two nurses and her daughter, Mrs Hamilton. As midnight approached, Mrs Hamilton left the room for a few moments but returned immediately she heard the two nurses screaming, in the belief that her mother must have died.

However, to her horror she found two men had entered the room, each of whom was holding a nurse by the arm and holding a pistol to her head. They threatened to kill them if Mrs Hamilton did not follow their instructions, telling her they did not want clothes but would be taking money and valuables.

One of the men remained with the nurses as the other escorted Mrs Hamilton to several rooms in which she was ordered to open the cupboards and drawers. She handed over a large quantity of cash and several items which included a silver snuff box, clasp knife, two candlesticks and a gold ring, the value of which amounted to £80.

Mrs Hamilton heard the voices of two other men coming from downstairs, urging their companions to hurry but she saw neither of these. Before they left, the men demanded the keys to the cellar, from which they took four bottles of wine.

Surprisingly, the armed men who entered the bedroom did not wear disguises and after their descriptions were circulated it led to the arrests of Lambell, Sangwell and also Charles Smith and John Weston. The four men stood trial and Lambell and Sangwell were convicted, mainly on the evidence given by the three women. However, there was insufficient evidence to convict the others, who were found not guilty.

*

On 30 August David Thomas was executed for the murder of John Matthews at Lambeth five weeks earlier on 20 July.

Thomas and his victim had worked together for several years at Rutter's mustard factory in Lambeth and were thought to be good friends. On the evening of Saturday 20 July, workmates saw them talking to each other and although the noise of the factory meant they could not be heard, they seemed to be on good terms. Thomas was seen to leave the premises and return five minutes later with a jug of beer which he offered to John, who took a drink. There was no struggle but John stumbled backwards, clutching his stomach, in which he had been stabbed and above the din could be heard to scream 'Murder, murder'. He staggered the fifty yards to his home and Thomas was detained by the foreman John Jones and another worker John Chappel, who took the knife he had used to commit the crime, from his hand and held him until the police arrived at the factory and arrested him.

John appeared to realise that he would not survive and said he did not want to go to hospital as he knew he would never return home and wished to spend his final hours with

his wife Catherine and his family. However he was persuaded to seek medical attention and was taken to Guy's Hospital where surgeons found his intestines protruding from a three inch long wound in the lower part of his stomach. He lingered for more than thirty-six hours before dying at four o'clock on the Sunday morning. He told Catherine that Thomas had stabbed him without warning and could think of no reason for the attack other than for an incident that occurred on the morning of the crime.

Before going to the factory they had called in at the Coach and Horses, where they each had a glass of beer. As he picked up his glass John drank to the health of the monarch saying 'Here is to the health of George IV, long may he live, happy may he be, blessed with content, bound or free'. The two men left the public house seemingly on good terms, but Thomas must have been offended by his friend's toast.

Thomas was convicted of wilful murder but the jury recommended mercy given his previous good character. However, the judge made it clear he could not agree and warned him he would die. Thomas continued to claim he was innocent and went to the gallows without offering any explanation for the crime.

<p style="text-align:center">*</p>

Having been convicted of highway robbery committed on 26 July at Newington, Edward Lee was executed on 6 September.

On the night the crime took place, local constable John Kinsey was on duty in Newington and noticed a group of four men, one of whom he recognised as twenty-two-year-old Edward Lee, a local criminal well known to him. Thinking they were probably up to no good, the constable decided to hide behind a wall and keep watch on them from a distance.

His instincts proved to be correct for only a few minutes later he saw them confront a man on foot, saying 'Damn your eyes, stand and deliver your money'. In response to this, the man produced two pistols before warning his attackers that he would shoot the first of them to come any closer. The men ran off and their intended victim assured the constable that he was unhurt and simply wanted to go home without reporting the incident. It was now almost eleven o'clock and the constable decided to follow in the direction the gang had taken and it would not be too long before he encountered them again.

After leaving the scene of their first attempted highway robbery, the four villains approached John Spicer and threatened to kill him if he did not hand over his money. He attempted to ignore them by continuing to walk towards his home but he was knocked to the ground by a violent blow to the head. One of the men, balancing himself by placing a hand against a wall, began to jump up and down on his head and neck, while another kicked him repeatedly to the body.

His pockets were gone through and the robbers seemed to be annoyed on discovering only 3s 6d and carried on beating him. John managed to cry 'Murder' before falling unconscious, but it was heard by John Kinsey, who fortunately was nearby. With his cutlass drawn, the courageous constable ran towards the robbers, who ran off in different directions. He decided to give chase to Lee and managed to arrest him after a violent struggle.

1822

John Matson Dalton was executed on 22 April for the rape of Matilda Atkinson, a child aged less than ten years. Dalton relied on two witnesses who claimed to have heard Matilda twice in the past say that her thirteen year old brother had raped her on several occasions. However, the girl gave evidence at the trial and insisted that Dalton was the rapist and the jury believed her rather than the defendant and his witnesses.

1823

On 20 January, Giles East was hanged for the rape of Sarah Potter, a girl described in the indictment as a child under ten years of age.

Despite his youth, sixteen year old East had lived as the husband of the forty-five year old mother of the victim, who was also named Sarah. She was charged with being an accessory after the fact and when the trial began she stood at her young lover's side in the dock, accused of attempting to conceal the crime. However, part way into the trial the judge, Baron Graham, apparently unable to believe that any mother would act in such a manner directed that she be discharged. The judge had been especially moved when the victim described her mother crying when she learnt of the crime.

There was an expectation that East would be reprieved because of his youth and it was widely reported that the foreman of the Grand Jury, Grey Bennett MP, who had found the bill against East, had made a strong appeal to the Government on his behalf. However, he issued a statement strongly denying this and added he thought it inconceivable that any member of the Grand Jury would make such an appeal. Furthermore, he suggested that although a strong opponent of capital punishment, he had never known a case of greater atrocity.

<div align="center">*</div>

On 24 April, Edward Hales became the third man within twelve months to be hanged for the rape of a girl under ten years of age, his victim being Maria Venner. This was despite strenuous efforts being made to save the eighteen year old, whose execution was postponed twice as a petition was being considered.

<div align="center">*</div>

Philip Stoffel and Charles Keppel having been found guilty of the murder of Elizabeth Richards at Clapham on 8 April were executed on 28 July.

Seventy-five year old widow, Elizabeth Richards lived with her old friend Jane Bell, who regularly visited church on most evenings, leaving Elizabeth alone in the house, as she did on the night of 8 April. That night, at a little before eight o'clock, neighbours noticed the front door of the house open and inside found Elizabeth's body. She was lying on the floor and an apron had been pushed into her mouth. Surgeon, Joseph

Rippon confirmed that she had been dead for less than two hours. There were no marks of violence on her body and he found that the apron had been put into her mouth with such force that one of her teeth had been dislodged and she had been suffocated. Her clothes were ripped as though the robbers had been looking for valuables or cash hidden on her person, the house showed signs of having been searched and the police concluded that robbery had been the motive for the crime.

There were no signs of a forced entry and lying close to the door was a brown paper parcel addressed to *Mrs Bell hat Mrs Richards, Clapham*. The police concluded that the intruders had used the supposed delivery of a package as a means of getting the victim to open the door to them. On examining the parcel, one of the constables found that it had been wrapped and tied in a manner used by employees on stage coaches and it emerged that Elizabeth's great nephew, Philip Stoffel was so employed locally and he was eventually detained for questioning three days later. He denied any knowledge of the crime but when asked to write a label similar to that found at the scene of the crime, he incorrectly wrote *hat* and his handwriting was similar to that used to write the name and address on the parcel. He decided to confess to participating in the robbery but denied that he had murdered Elizabeth.

Stoffel told of joining Thomas Scott and two others whose names he did not know on the night of the crime. He had indeed made the parcel to encourage Elizabeth to open the door and the men arrived at the house at about seven thirty. Scott had knocked on the door and distracted Elizabeth in a discussion as to the whereabouts of Mrs Bell, which allowed him and the two others to push past her. He and Scott searched the house while the two others held Elizabeth down and kept her quiet by grabbing her throat. Stoffel went upstairs and when he came down a few minutes later, Elizabeth was dead. The men left with items of clothing, a watch, three sovereigns, spoons, and a ring which one of the men had ripped from Elizabeth's finger.

Within two hours they had visited a fence and sold the proceeds for 22s, except for the watch, which was broken. The men spent the rest of the night drinking in a number of public houses. On the following day, Stoffel took the watch to be repaired by watchmaker William Alexander and on 10 April he arranged for Anne Hall, a prostitute with whom he lived, to pawn it for which she received 7s.

Thomas Scott had in fact surrendered to the police before Stoffel's capture and agreed to testify for the crown in return for a pardon. He confirmed that Stoffel had planned the crime for more than a month and to help had recruited Scott, Charles Keppel, and a man named Pritchard. He also confirmed that Stoffel had insisted that his great aunt should not be injured but that Keppel had murdered her anyway. Based on other information provided by Scott, officers travelled to Portsmouth where they found Keppel and Pritchard. Keppel was arrested but Pritchard escaped and was never captured.

Of the four men involved in the crime only Stoffel and Keppel were executed and at their trial it was revealed that on the morning of the crime, Keppel had appeared before the magistrates charged with another burglary but was bailed due to a lack of sufficient evidence to hold him in custody.

1827

Convicted of high treason for coining, Daniel Buckley and Jeremiah Andrews, two members of a gang known as the Vauxhall Road Coiners, were executed on 23 April.

In the summer of 1826, the Mint became aware of large quantities of counterfeit coinage, thought to be the equivalent of £100 weekly, was being manufactured in the capital and put into circulation. William Powell an investigator at the Mint was put in charge of the case and within a matter of weeks, a number of suspects, operating as a gang, emerged. It was clearly a well organised operation in which three premises were used. These were at 2 Shelton Lane, Greenwich, 8 Gloucester Street, Vauxhall and 23 Tiverton Road, Newington.

Surveillance was kept on all three addresses and the Mint operatives were helped by officers from the Hatton Garden and Thames Police offices. One of these, John Ellege observed two of the suspects, Daniel Buckley and Jeremiah Andrews, make several journeys in a cart, from which items were unloaded at Tiverton Road, where Daniel Pycroft lived. In September, Ellege rented a house opposite so that surveillance on the address could be maintained around the clock. Two women were regular visitors, Buckley's wife Mary and Mary Ann Patrick, both of whom would call empty handed but leave with heavy baskets. Another suspect, Shadrach Walker was living at the Shelton Lane address.

The investigators learnt that the gang purchased large quantities of sheet brass to produce the counterfeit coins and to allay suspicion, lied to their suppliers, telling them that large quantities of the material were required as they had a government contract to produce harnesses for the First Regiment of Life Guards.

On 23 December, William Powell decided it was time to pounce and the three houses were raided simultaneously at two o'clock in the afternoon. At Gloucester Street, Buckley was working on a coining press when the officers entered and he tried unsuccessfully to escape. There was a great deal of counterfeit coinage and paraphernalia including several dies, a lathe and other specialist tools. More equipment and counterfeit coins were discovered under the floorboards of the house, which appeared not to have been lived in but to have been used solely as a place of manufacture. At Tiverton Road, officers found the two women together with a press and two thousand counterfeit shillings. Walker was at Shelton Lane with a machine for cutting blanks from the brass sheets and a forge and bellows. All of the suspects were arrested along with Pycroft.

Buckley and Andrews were held on the prison ship *Port Mahon* to await their trial. Having initially given false names they quickly revealed their true identities and made what amounted to confessions to their crimes when speaking with Alexander Mitchell, the vessel's principal officer. Andrews complained that they made little money from the enterprise, making one pound for every gross of counterfeit shillings they produced. After paying for the brass and other expenses they only made two shillings and sixpence profit. Buckley said that with part of his share of the proceeds he had bought a coffin in which he could be buried following his execution.

The case against Walker was dismissed for lack of evidence and Pycroft was found not guilty of the capital charge of coining. Nevertheless, he and the two women were

charged with a lesser offence of assisting in the production of five hundred counterfeit coins. Only Mary Ann Patrick was convicted and she was sentenced to six months imprisonment with hard labour.

Of the gang therefore, only thirty-five year old Buckley and sixty-one year old Andrews were convicted and executed, but the Mint was convinced that a major gang of counterfeiters had been put out of action. It is not recorded if Buckley was buried in the coffin he had bought.

*

Joseph Swaine and John Thompson were hanged on 31 December for burglary. They had broken into the premises of haberdasher Mr Sizer in Newington and stolen property to the value of almost £500. Two women associates were transported for fourteen years.

Twenty six year old Swaine had been sentenced to death on an earlier occasion at the Old Bailey for wounding a watchman but respectable friends had intervened on his behalf and the sentence was reduced to twelve months imprisonment, which he served in Coldbath fields House of Correction. Thompson, although only twenty-three years of age was an offender well known to the Surrey police, who regarded him as the county's leading cracksman. Mrs Sizer became ill following the death sentences and had to stay in the country to recover her health. Her husband tried desperately to gain a reprieve for the burglars and as the prosecutor this would normally have some influence. However, the authorities regarded their past criminality as so serious that it was decided the executions should go ahead. This was despite the efforts of Swaine's friends once more on his behalf, one of whom wrote to *The Times*;

Sir,
Perceiving that the unfortunate young man, Joseph Swaine, is to expiate his crimes to the offended laws of his country on Monday next at Horsemonger Lane, perhaps a few remarks connected with his case may not be deemed unacceptable.

I know him and his family well, who are highly respectable. He was educated at the same school as I was at Mitcham, where his parents formerly resided. At that time, he was a steady inoffensive lad and bad fair to become an ornament of society, and a blessing to his parents; but coming to London a few years ago, at an age when the habits and passions of youth require to be checked, and being under no particular restraint, he gave himself up to those vicious propensities which introduced him to a circle of companions that has ultimately proved his ruin. This appears to be his second offence of any magnitude; through the respectability of his friends, great interest was made on his behalf by the gentry of Mitcham and its vicinity, who knew the family, for a commutation of punishment upon his first conviction, for a burglary in the city, among whom I believe, was a respectable banker, Mr Hoare of Fleet Street and which was attended with the desired effect. It was hoped this would have been a sufficient lesson to him, and been the means of deterring him from such evil courses in future; but I lament to say, such hope was soon blighted, for no sooner was clemency shown

him, and himself liberated, than he returned to his former associates in vice and crime, and, yielding himself up to this mode of life he plunged into irregularities and excesses which has cost him his life. It is impossible to erase early associations, and I cannot but feel deep regret at the untimely exit of an old schoolfellow (for at that time he had good qualities and was good natured). For his aged and afflicted parents I sincerely sympathise and trust they may have fortitude sufficient to survive the dreadful shock, he being the only son. He has a sister (an only one), who keeps a tavern in London and was, the last time I saw him, a fine comely young man. He is cut off in the prime of life, his age I think being about 26 or 27. May his untimely end be a warning to others. Every effort has, I understand, been made to save his life, but such was the nature of this second offence, that for the sake of justice it was considered necessary he should suffer. I am Sir respectfully yours &c
J. T.

However, one of Swaine's friends wrote a more sinister letter in the days immediately after his execution. It was part of an attempt to intimidate the Sizers as several young men would gather outside their home at night calling the couple names such as 'murderer'. The unsigned threatening letter, dated 3 January read as follows;

Sir, you would have received a letter from me before this time but illness prevented me. I write to beg of you to prepare yourself for another world, for in this you cannot long remain. Endeavour to get pardon and mercy for the two young men you were the occasion of having hanged last Monday. One of them was more than a friend to me and I have, as I have before, pledged myself to take the life of the murderer, yourself. And so far from considering it a crime, I am certain I shall be doing a good in ridding the world of a murderer. But as it is not my wish to extend my revenge beyond this world, I give you this timely notice to prepare yourself, for be assured you have not many days to live; for the first opportunity I have to be certain of my aim, your life is gone, though I may sacrifice mine in so doing. On the fatal day, last Monday, it was my intention of pistoling you in your shop, and for that purpose came between 10 and 11 o'clock, and saw you laughingly talking to a customer (though you had been that morning the occasion of murder), and considered you was not in a fit state to meet your Maker, and refrained from my purpose at that time; but now your family, after seeing your death, shall feel the misery that you and them have made me feel. Once more, therefore. I beg you to prepare yourself. Your wife, I find, is not at home, but I will find her out and make her suffer.

Fortunately, the intimidation stopped and Mr and Mrs Sizer were able to resume their lives without fear of reprisals.

1828

On 7 April Thomas Irons was hanged for the murder of Susan Froggatt on 29 September 1828 at Herne Hill.

Tensions below stairs in the household of wealthy gentleman J. B. Langton Esq. of Herne Hill, led to a brutal murder being committed there. Irons was a footman who had been employed by Mr Langton for two years and his victim, Susan Froggatt had worked there as a housemaid for eight years. Both murderer and victim were aged in the mid- twenties, and lived in their employer's house

On the day of the murder, Mr Langton left the house in the early morning, planning to return later that evening. The servants were thus left unsupervised, which Irons took advantage of by leaving the house on three separate occasions during the day. This annoyed Susan, with whom he had a poor relationship. He had obviously been drinking when he returned to the house at five o'clock in the evening, and had rung the gate bell to be let in. By the time Susan reached the gate, he had climbed over the garden wall, which annoyed her even more. Angry words were exchanged as she admonished him for being a nuisance and leaving the house without his employer's permission. He retorted that it was none of her business and he accused her of trying to get him dismissed. His voice was raised to such an extent that the cook, Harriet Fisk, who was in the kitchen, heard him add 'But if you do, I shall blow your brains out'.

The couple fell silent as they entered the kitchen, where they sat down with Harriet to have a drink of tea. Irons rose, saying he was going to his room but returned after a few minutes and resumed his seat. It was now six o'clock and the under-gardener, Nathaniel Jones came to ask Harriet to help him with some chores in the adjoining dairy. She agreed to do so, leaving Irons and Susan alone in the kitchen.

A few moments later, Nathaniel and Harriet heard the sound of a shot coming from the direction of the kitchen. The cook rushed to the window and peered in to see Susan lying on the floor having suffered horrific facial injuries. Irons was standing over her, a pistol in his hand and Harriet ran to the gate screaming for help. Nathaniel, meanwhile, with great presence of mind, bravely walked into the kitchen and Irons pleaded with him 'Put the fire out', for Susan's dress was on fire, so close to her had he been when he fired the pistol.

That having been done, Irons said he was responsible. He had placed the weapon on top of a dresser and stretching his arm out, continued 'And this is the hand that has done the deed'. He continued by telling Nathaniel that he had left the table to get the gun and he had sat with it hidden from view for fifteen minutes waiting to be left alone with his victim and the opportunity had arisen when Harriet went to the dairy.

Robert Young, a surgeon who lived nearby, confirmed that the lower part of the victim's jaw had been shattered and the roof of her mouth had been destroyed by the path of the shot, which emerged beneath her left eye. Later, Mr Langton would confirm that the pistol belonged to him and he kept it in his bedroom. His powder and shot were kept locked in a cupboard and had not been used by the killer. A powder flask and shot-belt were later found to have been hidden in the footman's pantry by Irons.

This, combined with his confession to Nathaniel, convinced the crown that this was a premeditated murder, stemming from the killer's belief that Susan was attempting to have him dismissed. This formed the basis of the prosecution case which was accepted by the jury.

1829

On 19 January, two men were hanged, William Page for horse theft and John Jardine for the attempted murder of his wife, Mary, at Newington on 6 October.

John and Mary Jardine had been married for sixteen years, for the first thirteen of which they had lived happily together. However, he began a number of affairs with other women and to treat his wife badly, which eventually led him to refuse to support her. As a result, she was admitted to the workhouse at Woolwich and the parish demanded that he pay part of his army pension towards the cost of maintaining her. He objected to this and he offered to allow her to return home, which parish officials agreed to and the deduction from his pension stopped.

On her arrival home, his ill treatment of her resumed and he failed to contribute towards her upkeep. On 5 October, close to starvation, she threatened to report him to local magistrates. The next morning she was boiling a kettle of water and left the kitchen for a few minutes. When she returned she saw her husband replacing the kettle lid, but thought nothing of it as he was in the habit of taking the hot water to shave.

She made herself a cup of tea and almost immediately fell ill, experiencing a severe burning pain in her stomach, which became distended. She vomited, which probably saved her life. Her husband seemed unconcerned and he left the house saying he was going for a walk. She was able to summon help and surgeon Mr Boast recognised what he thought were the symptoms of arsenic poisoning. He believed that the arsenic had been put in the boiling water.

A stomach pump was used and the contents were subsequently examined together with the water taken from the kettle, which led to the discovery of large amounts of the poison. The jury at his trial took just thirty minutes to convict him, and as there was little sympathy for him given the callous manner in which he had treated Mary, there was no hope of a reprieve for the forty-three year old Jardine.

As the two men stood on the gallows, Jardine remained calm but twenty-four year old Page lost his nerve and began to cry, shouting 'Oh my poor mother and sister, this sight would break their hearts'.

*

On 20 April Charles Kite, George King and William Wheatley were hanged for a burglary at the Teddington Lock-house over Christmas in 1828.

Four men, brandishing pistols, barged into the house of Mr Savory, the lock-keeper at Teddington and threatened to kill him if he did not reveal where his valuables were kept. Fearing for his life he told them and they left with twenty shillings in cash and other property amongst which was a copper medallion.

A few days after the crime, a man was walking in Kingston and noticed a child playing with a medallion, which rolled into a ditch. The man retrieved it for the child and as he handed it back he noticed an inscription giving Mr Savory's name, date of birth and address together with other personal details. He thought nothing more about it until a week later when he read of the burglary and recognised the lock-keeper's name. He

contacted Kingston's Constable Cooke, and the details subsequently provided by the child and his father led to the arrest of Kite, Wheatley, King and another man named William Young.

Young however, agreed to testify against his companions at the trial which was held the following April at Kingston Assizes. Young was also pardoned for his involvement in another burglary at the home of John Parker of Ham Common on 7 December 1828. His accomplices were said to have been Kite and King on that occasion also. He was also widely believed to have been involved with King in committing a murder in Hounslow some time earlier but there was no conclusive evidence.

Having given his damning testimony at the trial he acknowledged under cross examination he had acted similarly on a previous occasion and this had led to his then co-defendant, who was his brother, being executed. He acknowledged that he was attempting to save his own neck, but he insisted he was telling the truth. He was believed by the jury and the three men were convicted and sentenced to death.

PARTICULARS OF THE TRIAL AND EXECUTION OF

Charles Kite, Wm. Wheatley, and George King,

Who were Executed at Horsemonger-Lane Prison this Morning.

CHARLES KITE, Wm. Wheatley, and George King, were found guilty at the last Surry Assizes, held at Kingston, of burglariously breaking into the Teddington lock-house, and violently assaulting Mr. Savory, the keeper of the same, and stealing about £20 of money, a copper medal, and other property. The clue which led to the detection of these men was obtained in a curious manner :—A gentleman in crossing the country in that neighbourhood, observed a child playing with a copper piece ; it happened to roll into a ditch and the gentleman got it out, and restored it to the child, but, previous to so doing, examined it ; it was about three ounces in weight, & was inscribed with the name of Mr Savory, the date of his birth and marriage, and other matters connected with his family. A few days after the gentleman saw an advertisement stating the robbery, and describing this copper piece as part of the property stolen. He immediately communicated the circumstance to Cooke, a constable of Kingston, who, questioning the father of the child, obtained information which led to the apprehension of the above men, and a person named Young, who was allowed to turn King's evidence, and from his testimony the following particulars transpired ; that himself and the three unfortunate men broke into the lock-house, in December last, armed with pistols, in the dead of the night, and by threats and violence, compelled Mr. Savory to rise from his bed, and show them the place where his property was deposited. On Young's cross-examination, he admitted that on a former occasion he had also turned King's evidence and had given evidence as to an offence for which his brother was hanged ; and one of his present accomplices was his brother-in-law. These facts he deposed to without any appearance of compunction or shame ; on the contrary he seemed to think that any thing was right and proper, which could at all avail to save his own neck.

After the Jury had returned a Verdict of Guilty, Mr. Baron Garrow, in an impressive speech advised them to lose no time in making their peace with God, as from the magnitude of their crime he could not hold out any hopes of mercy towards them He then sentenced them to be hanged, and the unfortunate men heard their doom without expressing any feeling of sorrow.

Ever since condemnation these unhappy men conducted themselves with that penitence their situation required, and attended to the advice of the Reverend Clergyman with an earnest desire to get forgiveness for their past sins. The fatal instrument of death was fixed on Saturday, and this morning, being Easter Monday an immense concourse of persons assembled. At the usual hour necessary preparations were complete the drop fell, and this world closed on them for ever!

A copy of a broadside sold at the executions of the Teddington Lock House burglars. (*Harvard Law Library*)

At the conclusion of the trial Young was released but was recognised by a group of people who followed him. Initially they simply jeered him and called him obscene names but the crowd increased in size, became more threatening and he was jostled and had objects thrown at him. On Kingston Bridge the cry was heard 'Throw him over the bridge'. There were real fears for his safety and it was clear that the crowd was angry because he was a vicious criminal who had escaped punishment for what was viewed locally as a heinous crime. Fortunately for Young several constables arrived to rescue him and escort him from the town in safety.

1830

William Banks, convicted of housebreaking, was executed on 11 January, the only hanging in the county that year.

In the early hours of the morning of Wednesday 19 November 1828, four men broke into Grove Cottage, West Moulsey, the home of the Reverend William and Mrs Warrington. The burglars made their way to the couple's bedroom and burst in to find him asleep in his bed and his wife at her desk writing letters. She cried out 'Good God, we shall be murdered, there are thieves in the house'. Her husband woke up and rushed to the mantelpiece, on which he kept a loaded pistol. He picked it up and aimed at one of the intruders but when he pulled the trigger nothing happened, and one of the men responded by aiming his pistol at William but when the trigger was pulled it flashed in the pan. His wife begged the men not to kill her husband and no further attempt was made on his life. The vicar and his wife were tied up and together with their two female servants, were taken to the cellar. After several hours, one of the servants managed to free herself and the others, before raising the alarm.

The burglars ransacked the house and made off with £30, jewellery and other valuable items. They also took a horse valued at £80 and a phaeton. Having been informed of the outrage at Grove cottage, Constable Cook of Kingston tracked the men to Knightsbridge, where the trail went cold. Three Bow Street Runners, Ellis, Ruthven and Bishop visited the scene of the crime, and they immediately suspected that the burglars had been acting on information about the layout of the house, the habits of the Warringtons and the location of the stolen items. One of the servants, Fanny, had been called by her name by one of the burglars, and it was she who had managed to untie herself and release the others, long after the gang had left the scene. It was also believed that she had removed the bullets from William's gun, which meant he could not put up any meaningful resistance. However, nothing could be proven against her and no arrests were made; it seemed that the crime would remain unsolved.

However, in July the following year, a burglar named Barnett was convicted of a burglary in London and was sentenced to be transported for life. Wishing to avoid such a fate, Barnett offered to provide information on the Moulsey Gang as the burglars had become known, in return for his freedom. Keen to solve this notorious crime, the authorities readily agreed to the offer, and Barnett gave five names; William Banks, John Smith, William Johnson, James Taylor and William Potts.

Banks was a well-known offender, who had said many times in the past that he would never be taken alive. An experienced Bow Street Runner named Craggs was given the task of capturing him. Craggs disguised himself as a butcher and for several days visited the known haunts of the suspect. Eventually, he spotted Banks and rushed up to him, putting a pistol to his head. There was nothing Banks could do and there was no struggle. As Craggs led him away, Banks muttered 'I am a dead man'. The Warringtons were able to identify Banks as one of the intruders, but emphasised that he had persuaded his associates not to harm them.

All of those named by Barnett were arrested and despite it emerging that Potts had pawned a pair of Reverend Warrington's shoes which had been taken from the cottage, there was insufficient evidence against them and Banks was the only man charged with having taken part in the crime.

1831

On 10 January James Warner was executed for arson at Albury on 14 November 1830.

In late 1830, the countryside of south east England was in turmoil. There was widespread rioting as agricultural workers, who were experiencing job shortages, reduced wages and increased prices for staple foods, attacked wealthy farmers, destroyed their new mechanised threshing machines which could do the work of several men, together with what were perceived to be symbols of repression such as workhouses. The church did not escape attacks as local clergymen continued to benefit by taking a levy from the local harvest, a custom left over from the days of the tithes.

Surrey did not escape the unrest and the county experienced a number of disturbances and acts of incendiarism. At Caterham in early November, out buildings on the farm of Mr Simpson were set alight causing damage estimated at more than £2,000. However, many of his neighbours, who included the poorest agricultural labourers, rushed to the scene and helped to save much of his property.

A few days later, a large haystack on a farm at Banstead was set alight and once again most of the village were on hand to help douse the flames. However, this was intended to be a diversion, for on the opposite side of the village a much larger fire was started at Mr Turner's farm. Fortunately, the Carshalton fire engine arrived and damage was restricted two stacks of corn. In the days leading up to the fire, several of Banstead's leading residents had received threatening letters signed by Captain Swing, the fictitious figurehead of the movement.

The authorities came down hard on those arrested for participating in the unrest and there were many arrests in the counties of southern England. Of these, a number were sentenced to death but many were later reprieved and were transported. Nine are thought to have been executed for direct involvement and thirty-year old James Warner, the only Surrey man to be hanged, was in common with most of the others who stood on the gallows, convicted of arson. There can be little doubt that his own loose tongue was the main cause of his arrest, conviction and execution.

James Franks, the owner of a corn mill, which stood next to his house at Albury, was awakened by the unmistakeable sounds of a fire at four thirty on the morning of 14 November 1830. From his bedroom window he saw that the mill was ablaze and as he looked at the scene before him, he heard the sound of a gun being fired and the window of his bedroom shattering into fragments. The flames illuminated the immediate vicinity and he saw the figure of a man running away across the land of his neighbour, Mr Smallpiece. He could not see his face but noted that he was wearing a brown frock coat.

Family members, servants and neighbours, both rich and poor, helped as best they could but could not prevent the mill from being destroyed together with one hundred loads of corn and a large amount of flour.

Within a matter of hours, the suspected arsonist had been identified. The mill owner's brother, Henry Franks, had a clear view of the fleeing man. He did not know him but information provided by several others led to Warner being detained and Henry was able to identify him as the man he had seen running from the scene but could not swear that he had been carrying a gun.

Four young men, on hearing of the fire reported an incident which occurred at seven o'clock on the Saturday evening, a few hours before the fire. Blacksmith Matthew Mansell, painter Richard Moore, sawyer James Challing and carpenter George Wilkinson were in Guildford and were approached by Warner, who had clearly been drinking. He began discussing the state of the economy and the greed of local employers. He concluded by saying 'If you owe any person a grudge, don't go in a mob, but do it secretly'. As he walked away, he told them they would learn something of great importance in the morning. The four men mocked him thinking he was a boastful drunkard, but on hearing of the fire they contacted the police.

Warner continued drinking that night in Guildford at the Queen's Head and the White Hart and walked as far as Albury with barmen James Niblett and Thomas Myon, both of whom also contacted the police, describing his tirade against the rich land owners who exploited the poor. Local magistrate, Henry Drummond ordered a search of Warner's house, which led to the discovery of a gun thought to have been fired recently and a brown frock coat similar to that worn by the man seen fleeing the fire.

It was also revealed that Warner had worked for Mr Franks, but had been laid off two years earlier. Mr Franks insisted this had been solely due to lack of work but Warner had been convinced it was because he was wrongly thought to have badly beaten his employer's horse. This was confirmed by Richard Tidy who was working at the mill with Warner and remembered him telling him 'Mr Franks is saying I beat his horse and he'll get no good for it'. Richard took this as a threat and had thought it advisable to inform Mr Franks at the time of what had been said.

At his trial, Warner pleaded not guilty and called one witness in his defence, his lodger George Boler, who claimed that Warner was at home at the time of the fire. However, under cross examination it emerged that he could only swear to having seen the defendant at seven o' clock that morning. The jury took little time in convicting him of arson and the charge of shooting at Mr Franks was not continued with.

Mr Justice Bosanquet placed the black cap on his head and in sentencing him to death told him 'Whatever your motives may have been, whatever feelings may have rankled in your mind after the lapse of two years against your late master, or whether your crime has been instigated by the same spirit which has driven others to the commission of similar offences, it is clearly manifest that you carried your wicked design into execution. And from one advice, if such it can be called, which you held out to the young men at Guildford, when you told them, if they owed any person a grudge not to join in a crowd, but do it in secret, it is clear you meant to urge these young men to the commission of crimes which have of late become so lamentably prevalent, and which nothing under God's providence, but the strong arm of the law, can check and repress'.

On the morning of his execution, Warner was overcome by fear and in a state of collapse and had to be carried to the scaffold. Whatever the motive behind the crime, his hanging was used by those intent on causing further unrest. On the Thursday following his execution a note was found at the Guildford Workhouse after shots had been fired into the bedroom of the institution's master, which read as follows;

> Warner is murdered, Franks, Drummond and Smallpiece shall die. I could clear him at the place, you fake-swearing villains. We fired the mill. Starving and firing shall go together.

Nevertheless, there would be no more serious incidents in Surrey and within a short space of time the unrest came to an end throughout the country, due in no small part to the harsh sentenced passed on those convicted of taking part.

*

On 22 August, Fifty year old Edward Hogsden was executed for the rape of his seventeen-year-old daughter Harriet at Ashstead Common on 27 July.

At four o'clock in the morning, on the day of the crime, Harriet was lay in bed, her baby at her side, when she heard her mother leave the cottage to go to work for local farmer Mr Hugget. Two hours later, Harriet woke up once again as her father returned home and went to his bedroom. His mother had been buried the previous day and he had kept vigil in the churchyard to deter body snatchers violating the grave.

After a few minutes, Harriet heard her father leave his room and moments later he climbed into her bed, demanding that they have sexual intercourse. She pointed to the baby at her side, of which he was the father, and told him that should she once again become pregnant she would not survive. However, he ignored her pleas to be left alone and ordered her to be quiet, threatening to kill her if she did not obey him. After raping her and as he dressed in readiness for work at Mr Hugget's farm, he told her that as far as he was concerned she could drown herself and the baby.

After she was sure her father had left, Harriet, who now decided she could not cope any longer with her father, sent her sister to fetch their mother to whom she revealed what had been happening for several years. Local magistrate, Baron De Telssier was

advised and he immediately issued a warrant for Hogsden's arrest. Following his detention the Baron asked Hogsden if there was anything he wished to say to which he replied 'There was always temptation in the way. She is no daughter of mine. I admit I had connection with her, but she was always agreeable'.

At his trial, Hogsden described Harriet as an immoral girl and claimed that several years earlier he had returned home unexpectedly and discovered her in bed with a packman. He had thrown him out of the house after which Harriet had threatened him with a knife saying she would kill him if he ever interfered in her affairs again. He continued by claiming that on the morning of the alleged rape, he had again found the same man in Harriet's bed and after again ejecting him from the cottage, Harriet had sworn to have her revenge.

He insisted this was therefore a mischievous prosecution and he was innocent of the crime. Nevertheless, he acknowledged he had been having sex with her since she was nine years old. Clearly nobody believed his account, or that Harriet was not his natural daughter, or that she had willingly agreed to comply with his demands that day or in the past. After being convicted by the jury within moments of the evidence being concluded, the judge sentenced him to death, and warned him not to expect mercy.

1833

On 7 January John Hallahan was hanged for a highway robbery committed on 7 October 1832 at Wickham.

David Green, a seventy-two year old draper, was on his way home to Addiscomb on the evening the crime was committed and was carrying a bundle containing a large quantity of his wares. Suddenly, a man who was carrying a large stick, leapt out from a hedge and dragged David towards a ditch at the side of the road. The assailant beat him violently about the head and David fell to the ground badly stunned. The beating continued until, on hearing the sound of someone approaching, the attacker grabbed his victim's bundle and ran off.

However, he left behind some items he had in his possession, namely a basket and a handkerchief, which David identified as one he had sold to a man named Hallahan. Police also learnt that the suspect had owned a basket similar to that left at the scene of the robbery.

Following his arrest and subsequent trial, Hallahan maintained his innocence to the very end but acknowledged he had committed a great many other serious crimes.

*

On 12 August Henry Nicholl was executed for an offence of sodomy committed on a boy named Lawrence in late 1832.

Fifty year old Nicholl enlisted in the army as a young man and served with distinction, seeing action in the Peninsula War. He was from a respectable family, a brother having served as High Sheriff of Bedfordshire in the past. His downfall began in mid-November

The trial and execution of Captain Henry Nicholl attracted a great deal of interest. (*Harvard Law Library*)

1832 when the mother of a fourteen year old boy reported that her son was missing. She had not seen him for several days after he had told her he had been offered a live-in post as servant to a man he had met recently, but could give her no name or address of where he would be working. Having taken the barest details from the distraught woman, Constable Pople was given the task of finding the missing boy.

The officer managed to do so and upon questioning him it became evident that he had fallen into the clutches of a group of homosexuals who enticed young boys with the offer of work, but who had to submit to their sexual demands. He appears to have been fortunate to survive and he identified Nicholl and others as those responsible for his ordeal. There were some arrests but Nicholl evaded capture for several months. One of those arrested initially was a man who identified himself as Captain Thomas Beauclerk, who was also accused of assisting Nicholl to escape.

Beauclerk was found to be an imposter, whose actual name was Clarke, and who following his arrest committed suicide in his cell at Horsemonger Lane Gaol. This followed an appearance before magistrates on 20 November, at which he learnt the extent of the evidence against him and decided that all was lost. The next morning the turnkey discovered his body after he had cut his own throat with a knife he had managed to conceal.

The gang to which Nicholl was suspected of belonging was thought to be responsible for the abduction, rape and brutal murder of thirteen year old Robert Paviour in February 1833. The boy was found to have two broken arms, a fractured skull and horrific internal injuries suggesting he had been raped by a number of men. It was never proved that Nicholl had taken part and three men who were accused and stood trial for the crime were cleared. Nobody was ever convicted of the murder.

Nicholl was eventually captured and was the only member of the gang to be found guilty of any crime. He too had intended to avoid the noose by committing suicide, for on his return to the gaol following his conviction, a long sharpened nail was discovered hidden in his clothing. He was abandoned by his family and as he prepared himself for his execution he thanked the governor and his staff for their kindness to him, which he had not expected given the nature of his crime. He walked firmly to the roof of the gaol, where he was met by an unsympathetic crowd who made their abhorrence plain. He died bravely, like the soldier he had once been.

1834

Henry Hughes was hanged on 7 April for the rape of eight year old Emma Cook in Penge Wood, Norwood on 3 March.

Emma visited the wood to pick flowers but before she had the opportunity of doing so, she met Hughes who was a former neighbour of her parents, John and Mary. He promised to take her to a place where she would find some pretty flowers, but when they reached a deserted spot he pushed her forcefully to the ground, threatening her 'Lie still or I will eat you'. He placed his hand over her mouth to prevent her from screaming for help, and raped her. He ran away when he heard footsteps approaching, which were those of youngsters Augustus Bedster and Christopher Rice. They discovered the distressed little girl and took her home. Surgeon, William Street discovered many scratches, particularly to the lower part of her body which was covered with blood. The medical examination proved that she had been raped.

She was perhaps too young to fully appreciate the true extent of her violation but she knew she had been severely injured by her attacker, for when Hughes was brought to her bedside to be formally identified, she recoiled and cried out 'Oh mother, kill him for he has made me very ill'.

James Garside and Joseph Moseley were executed on 25 November for the murder of Thomas Ashton at Werneth in Cheshire on 3 January 1831.

In late 1830 and the early months of 1831, the Cheshire textile operatives were involved in a bitter dispute with their employers over reduced wages and deteriorating working conditions, which led to the closure of fifty-two mills. Samuel Ashton was viewed with particular antipathy by the strikers, given the harsh attitude he adopted towards them. He owned two mills, the Apthorne which was managed by his son James and the Woodley, of which his other son, Thomas was manager. His views led to a decision being taken to teach him and the other owners a lesson, which would lead to three deaths.

Hughes lures his young victim to a secluded spot. (*Author's Collection*)

Hughes awaits his appointment with the hangman. (*Author's Collection*)

Right: There was little sympathy for
Hughes, whose execution was witnessed
by thousands. (*Harvard Law Library*)

Below: A contemporary sketch of the
murder scene of Thomas Ashton.
(*National Archives*)

On the night of the murder, Thomas was walking alone, close to Werneth, when he was shot dead. There were no clues and despite the offer of a reward for information leading to the killer, no arrests were made and after three years had passed it seemed that the murder would remain unsolved. However, a decision was made to offer a pardon to any participant to the crime but who had not fired the fatal shot and who would provide evidence for the Crown; there was an immediate response.

William Moseley came forward to confess to his own involvement in the plot to murder Thomas and to name his fellow conspirators, in return for which he would avoid the gallows. He named thirty-four year old Garside as the man who fired the shot and Moseley's twenty- five year old brother Joseph, as the other man who had taken part in the crime. On the Wednesday before the murder, the informer told of meeting the other two in the Stag's Head at Marple Bridge, where he was asked to help them. He was out of work and agreed in return for payment as he needed the money.

The assassins were paid £10 which was handed over to them by joiner Samuel Schofield, a leading militant trade unionist. Afterwards they knelt down and holding a knife each of the conspirators took it in turn to swear the following oath 'We wish God would strike us dead if we ever tell'.

Schofield avoided prosecution but Garside and Joseph Moseley stood trial at the Cheshire Assizes on 4 August 1834. Following the informer's testimony, which proved to be crucial, the two prisoners were convicted and sentenced to death, their executions being scheduled for the following Monday in Chester. However, a dispute arose, when the Sheriff of the county of Cheshire argued that recent changes to the administration of justice meant he was no longer responsible for carrying out the executions and it was now the task of the Mayor.

The Mayor insisted this was not so and as neither party to the dispute was prepared to give way, the executions had to be postponed on a number of occasions. Eventually, it was decided that the matter should be settled before the judges of the Court of King's Bench. The condemned were taken to London in mid-November in the custody of the Governor of Chester Castle and held in Newgate Gaol. Finally, it was decided that the Sheriff of the county of Surrey would take responsibility for the executions.

Garside submitted a petition in which he sought a pardon, claiming that it was he who had provided vital evidence for the Crown, that he had been a bystander and that it was the Moseley brothers who committed the murder. The petition was submitted on Saturday 22 November and was sent to the Duke of Wellington who was the acting Prime Minister, the Tories having recently been returned to power and Sir Robert Peel being temporarily out of the country. Later that same night Garside's barrister received the following reply;

Sir, I am directed by the Duke of Wellington to acknowledge the receipt of your letter of this day's date, with its enclosed petition of James Garside, a convict under sentence of death, in the custody of the Marshal of the King's Bench Prison, and to express to you his Grace's regret that he can perceive no sufficient ground to justify him, consistently with his public duty, in recommending the prisoner to his Majesty for an extension of the Royal Mercy.

I am Sir, etc.
S M Phillips.

Every Interesting Particular relative to the TRIAL and Order for

EXECUTION

OF

James Garside and Joseph Mosley,

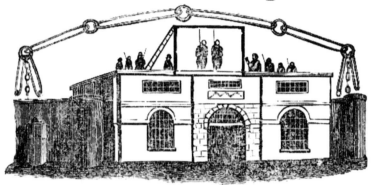

THIS MORNING, AT THE COUNTY GOAL, HORSEMONGER LANE,

For the MURDER of Mr. ASHTON, at Werneth, Cheshire.

[The following columns of small print are largely illegible due to the degraded condition of the original broadside.]

COPY OF VERSES.

DRAW near, ye old both young and old, & listen to my tale,

Despite the murder being committed in Cheshire, Garside and Mosley were executed at Horsemonger Lane Gaol. (*Harvard Law Library*)

On 1 December Frederick Finnigan was executed for the murder by drowning of his daughter, Catherine Matilda aged twenty months, at Camberwell on 8 August.

George Pitt was fishing in a ditch which ran parallel to the Grand Surrey Canal. It was about six feet wide and three feet deep and the bed was extremely muddy. As he fished he saw the little girl's body on its side and with the help of passer-by James Carter managed, with some difficulty, to pull her free. The men later told police that they believed she would not have been so embedded in the mud had she simply fallen into the ditch.

They thought they could detect a weak pulse and rushed to the Albany Arms where she was placed into a warm bath. Matthew Askin, a surgeon, arrived but declared her dead and gave the cause as drowning. He believed she had been in the water for less than one hour. There were no signs of physical violence but having heard the account given by the men who discovered her, the local constable was convinced a murder had taken place. He believed she had been held down forcibly, and later that day information was received identifying the dead girl and her probable killer.

Frederick and Jane Finnigan were married three years earlier but had been separated for three months. The couple had agreed that Frederick's father John would look after Catherine with the help of his own daughter Matilda at their home on New Church Street, Camberwell. Jane was to live with her mother on George Street and she would keep custody of the couple's newly born baby. The reason for the separation was Finnigan's apparently unfounded belief that Jane had been unfaithful. Nevertheless, they maintained regular contact and met as a family several times each week.

At a little before two o'clock on the afternoon of the murder, Finnigan called on his wife and took the infant from her. He was in a highly agitated state and begged her to leave the country with him. Astonished at his behaviour she asked why they should do such a thing and continued by saying 'Don't say you are about to quit the country. We shall be happy again'. She was horrified when he responded by saying they could never be happy unless they emigrated, adding 'I have committed murder'. She demanded to know where Catherine was to which he answered 'She is happy, she is in heaven'. When it became obvious that Jane would not go with him he began to walk away and asked her to meet him on Clapham Common the following day.

Fortunately, Jane's cousin, Elizabeth Barnes heard the raised voices and approached the couple. She took the infant from Finnigan's arms, so he left alone and Elizabeth was able to comfort her now hysterical cousin. It cannot now be known with certainty if by Jane refusing to leave with her husband she had saved her own life, and if by taking the baby from his arms, Elizabeth had saved the infant, for Finnigan may have intended killing them both.

Elizabeth later told her brother George Barnes who decided not to leave matters to the police alone. He went in search of Finnigan in the vicinity of Clapham Common, where he found him the following day. He told Finnigan that Jane was too ill to come herself but he would take him to her. As they approached the Plough at Clapham, George suggested they have a drink. Finnigan agreed and as they entered the inn, George grabbed him and with the assistance of other customers managed to detain him, after which he was handed over to the police.

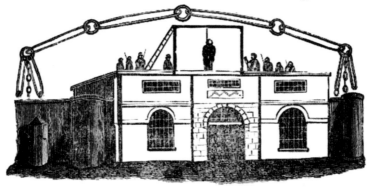

A full Account of the Interesting TRIAL and
AWFUL EXECUTION
OF
Frederick Peter Finnigan,

THIS MORNING, AT THE COUNTY GOAL, HORSEMONGER LANE,
For the MURDER OF HIS INFANT DAUGHTER.

FREDERICK PETER FINNIGAN, a middle-aged man, was indicted for the Wilful Murder of his infant daughter, Charlotte Matilda, by having by force and violence thrown or forced her into a ditch, by which she was suffocated and killed. The prisoner was also charged on the Coroner's warrant.

The trial took place at the Old Bailey, before Mr. Justice Park, on Friday last, Nov. 25, 1834.

Mr. Adolphus stated the case for the prosecution, which had been instituted by the parochial authorities of Camberwell.

George Pitt, the youthful son of G. J. Pitt, stated that he resided in Broadwall-row, Westsquare, Camberwell. On the 8th of August last, he went to fish in the Surry Canal, Camberwell, and in a ditch near thereto, he saw a child lying on its side; it was not quite covered with water. Witness then called out to a man named Carter, who was about 100 yards off.

Cross-examined—It was close to the foot-path.

James Carter, living in Johnstreet, Camberwell—Witness was working near the Surry Canal. The last witness called to him, that there was a child in the ditch. Witness pulled out the child by the arm, but with some difficulty, as it was imbedded in the mud. Witness ran to the Albany Arms, a short distance off, with the child, and then ran to Mr. Haskin, a medical man. Before he came, a quarter of an hour had elapsed since the child was taken out of the water. Every means was resorted to to restore life, but they all failed.

In answer to a question from the Judge, he said there were no marks of a man's foot on the top of the bank, nor was it likely there could be, as the feet of witness did not make any impression. The nature of the bank would not retain the mark of the heaviest shoe.

Mr. Matthew Haskin, a surgeon, residing at Camberwell, deposed that he used every means to restore animation to the child, but without avail.

Lucy Broadwood, of Camberwell, stated that she lodged in the same house with the prisoner, whom she had known twelve months. The prisoner and his wife had separated. On the 8th of August about nine o'clock, she saw the prisoner with the child near the bridge, going from his father's house. Witness asked him if he was living with his wife. He said he was, and that Mr. Goddard was going to set them up in business. Heard of the death the next day, but did not attend the inquest, not being called upon.

Mary Matilda Finnigan and John Finnigan, were called upon their recognisances, but did not answer.

Mr. Justice Park said he could feel for the relations of the prisoner, who refused to attend;

but justice must be enforced, and, therefore, the recognisances must be estreated, and the parties proceeded against.

Elizabeth Barnes, single woman, stated that she was first cousin to the prisoner's wife. The prisoner and his wife had separated about six months. There was another child, a baby in arms, which lived with the mother. Between nine and ten o'clock, the prisoner and his wife were together in Camberwell, in the house in which witness lived. Heard the prisoner exclaim "I am a murderer!" His wife cried out "Oh, my God!" The prisoner said "My child is happy in Heaven." Mrs. Finnigan then fainted. The prisoner had the baby in his arms then. Witness said to him, "Oh, Fred, don't say so!" He replied, "Betsey, you think I am trifling; but the child is happy in Heaven, and will want no more earthly provision." He then kissed his wife and she kissed him, and he went away. Mrs. Finnigan was assisted to her house. The prisoner had a black hat and was round it, and had very full whiskers. His wife's name was Jane. The next day, Saturday, at six o'clock, witness saw the prisoner. The black crape was not then round his hat and his whiskers had been shaved off. Witness went to his father's house to inquire after the child. On the Saturday his hands were dirty, and there appeared dried mud thereon.

Cross-examined—Did not know that on the day he was married he made away with his goods and tools. Had never seen him in a state of insanity.

By Mr. Justice Park—He wore the crape for his deceased mother.

George Barnes, a shoemaker, knew the prisoner and the child; heard of its having been destroyed about six o'clock on Friday, and, in consequence, sought for the prisoner, and found him on the Saturday morning in Acre-lane, near Clapham. Witness asked him what he did there. He said 'How did you know I lived here?' Witness asked him if he had seen his wife; he said he had not. The prisoner then said 'You are betraying me; I am not frightened.' Witness said he had seen his wife's sister, who told him they had an appointment. Witness told him his wife was too ill. He said he had requested her sister to come. Witness told him she did not like to come, and he had come in her place, and was ready to make any communication, and would endeavour to bring together. They then walked on towards Clapham-Common; when a witness asked him to have a glass of ale, and directly they got inside the door of a public-house, witness said to him 'You are my prisoner,' he said 'I am not frightened.' He said 'Don't you make a noise about it, I will go with you wherever you like.'

Witness took him to the station-house, and from thence to Union-hall.

Thomas Clifford, beadle of Camberwell, said he knew the deceased when living; the body he saw at the Albany was the same; he had seen the child in church with the clothes it had on when it was found. The distance from the prisoner's father's house to where the body was found was about 800 feet.

This was the case for the prosecution.

The prisoner, in defence, said he laboured under great excitement of mind, and could not tell how the child came by its death.

Mr. Justice Park minutely summed up, and left the case to the Jury.

The Jurors consulted for a few minutes, and the Foreman, in a faltering voice, pronounced a verdict of

GUILTY—DEATH.

Proclamation having been made for silence, The Recorder addressed the prisoner in an impressive manner, remarking on the great enormity of his offence, and conjuring him to employ the few hours he had to live in supplication, prayer, and repentance. The Judgment of the Court was, that he be removed to Horsemonger-lane gaol, and to be taken from thence, on Monday morning next, to the place of execution, and there be hanged; and that his body be buried with the precincts of the prison.

The prisoner did not evince any particular emotion, resting against the side of the dock, and stedfastly looking at the Recorder.

On Saturday morning early, he was removed from Newgate to Horsemonger Lane, which prison he entered with a firmness of step, and a degree of self-confidence, that astonished all who saw him: he seemed like one who could calmly die on Death; but there was nothing unbecoming in his behaviour.

The Execution.

At few minutes after nine o'clock this morning, he ascended the fatal scaffold, with the same firmness that he displayed throughout. It was imagined, that on account of the recent execution at the same place, that the banner of spectators would be insignificant; but it was not so, the crowd was immense, and, as usual there were a great number of females.

Finnigan's crime shocked the nation. (*Harvard Law Library*)

At his trial when asked if he had anything to say in his defence, Finnigan claimed to have had no recollection of events and there was little surprise when after only a few moments deliberation the jury found him guilty of wilful murder. In the days leading to the execution he continued to blame his wife for his problems as evidenced by the contents of the following letter he wrote to a friend;

My dearest friend,
I write you this as a token of my cares, which are brought on through a base and impudent wife, and which has laid me open to the laws. I could with ease have borne her false and bitter reflections. My wife, my only wife, has been the cause of all my pain and sorrow; but I now freely forgive her all, and I'll rest now in the grave.

On the eve of his hanging, Finnigan offered some explanation for his actions when he told his gaoler that he had become jealous and sought revenge on his wife as he believed George Barnes was the father of Catherine.

1836

On 11 April William Harley was executed for a burglary at Chipstead on 2 September 1835. Following his execution, all subsequent hangings in the county were restricted to those convicted of murder.

Harley was tried with James Hills and William Fisher alias Curly Bill, for breaking into the home of sixty-six year old widow Mary Ann Long. Also in the house that night were her sister, Mrs Schofield and her nephew Captain Rankin. In the early hours of the morning, Mary was woken by the sound of her dog barking in the garden. Fearing intruders, she opened the bedroom window and shouted into the darkness to anyone who was there that they should leave immediately. Nevertheless, a short time later a man armed with a large stick burst into her room and attacked her. There was a struggle during which she was hit on the head and also on her shoulder. Captain Rankin had been disturbed by the noise and appeared brandishing his cutlass, causing the intruder to run away.

There was silence for thirty minutes, but then Mary again heard the voices of up to a dozen or more men in the garden after which the door to the house was smashed open. A different man came upstairs, demanding to know where her money was hidden. She told him that all her cash and valuables were in the bank, but another man's voice could be heard encouraging his companions by shouting 'Go to it my boys'.

Captain Rankin had by this time loaded his gun and as the intruders came upstairs he pulled the trigger and wounded Hills in the shoulder. All the men fled and Mary later discovered they had drunk two bottles of wine and eaten fourteen of her apples. They had taken a few items including a watch, which was later sold to the landlady of the Spotted Dog at Turnham Green for 4s and 6d.

Hills had suffered severe injuries which meant he had to seek medical treatment and this led to his being arrested within a short time. He in turn incriminated Harley and Fisher, the only men he said he knew the identities of, in the hope he would receive a

A broadside giving details of the crime, trial and execution of the Chipstead burglar. (*Harvard Law Library*)

lenient sentence. However, at the conclusion of the trial, Fisher was acquitted but Hills and Harley were sentenced to death. A reprieve was sought for the informer which was granted, meaning Harley was the only person hanged for the Chipstead burglary.

A popular broadside sold at his execution, contained an example of the doggerel verse often included in such street literature;

Good people all in Surry,
Now do listen unto me.
These few lines I do unfold
Of the Chipstead Burglary.
On the Second of September,
Those men was fully bent,
To rob and Plunder the mint house.
It was their whole intent.

In the dead of night, the dog did bark
The widow Long, jumpt out of bed,
She then threw the window up
She being full of dread,
To see those Ruffians round her house,
To them she did then say,
If you don't be off we'll fire at you,
And take your lives away.

Down to the kitchen she did go,
For the fire arms all in haste
Their lives being in danger,
They had no time to waste
But in her haste she forgot
The powder and the ball,
The Captain, to fire was determined,
And cause their downfall.

Then they broke into the parlour
Where they had a treat,
They regaled themselves with wine,
And some apples they did eat.
Mrs Schofield heard them on the stairs
For mercy she did call
And if you don't give us £50,
We'll surely murder you all.

Oh! Then the Captain quite resolute
His musket then he aim'd
He fired at Hills and wounded him,
For which he was not to blame.
They run away and left him,
Their hearts was fill'd with fear,
They sold the watch for 4s 6d,
And a little beer.

When in Horsemonger Lane Gaol,
Those two wretched men did cry
The Lord have mercy on my soul,
Alas I am doom to die,
A warning take by my fate,
As plainly you may see,
On Monday morning I did die,
Upon a fatal tree.

1846

On 5 January Samuel Quennell was executed for the murder of Daniel Fitzgerald on Thursday 28 November 1845 in Newington.

The murderer and his victim had been friends for some time before the crime was committed. They were labourers in the building trade and both were employed by Samuel's half-brother, William Quennell. A few days before the murder, Samuel confided to Daniel that he was disappointed with William and that if he had sufficient funds he would set himself up in business as a builder and attempt to lure his customers away.

This appeared to be nothing more than wishful thinking on the part of a disgruntled brother and there was little chance of it happening. However, Daniel mentioned it to William, which would prove to be a fatal mistake. William was annoyed that his brother had spoken of him in this way after he had given him employment. He did not immediately dismiss Samuel but asked him to look for alternative employment. William told his wife Julia, who paid his workmen their wages and when she next saw her brother-in-law on Saturday 23 November, she berated him for his ingratitude.

Samuel felt betrayed by his supposed friend and was intent on revenge. That evening he visited the shop of Mrs Tubbs to buy a pistol and any hopes that he would not be remembered and later identified were dashed when he damaged a weapon he was examining and was required to pay two shillings towards its repair. He purchased another for five shillings.

In the five intervening days he did not calm down and on Thursday 28 November he called at Mr Welling's shop on Walworth Road and asked for one pennyworth of his best gunpowder. He knew Daniel lived on Peacock Street and he was waiting there for him when he finished work at five o'clock that evening. There were several witnesses who saw him calmly approach his victim and shoot him dead. It was clear that this had been a premeditated crime and that there was little chance of a reprieve once the death sentence had been passed.

1849

Frederick and Maria Manning were hanged on 13 November for the murder of Patrick O'Connor at Bermondsey on 9 August.

It was August 1849 and Patrick O'Connor, a wealthy single man in his fifties, had last been seen by his friends and work colleagues at the Customs House on London Docks, several days earlier on the afternoon of Thursday the ninth. He was seen by friends William Keating and David Graham and told them he was on his way to dine with Frederick and Maria Manning at their home, 3 Miniver Place, Bermondsey. Later, he was seen by another friend, James Coleman on Old Weston Street, about one hundred and fifty yards from Miniver Place.

On the following Sunday, Keating and Graham called at 3 Miniver Place, where they spoke to Maria Manning. She told them she had not seen Patrick since the previous

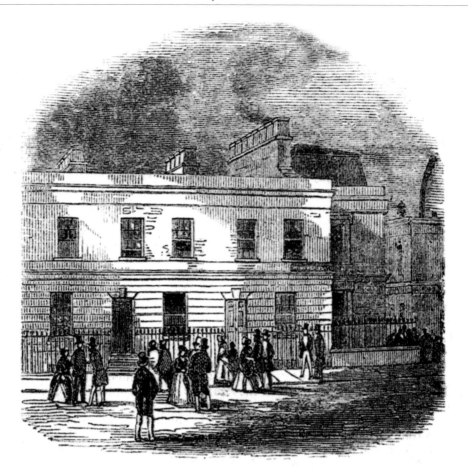

Above: The home of the Mannings, 3 Miniver Place, where the murder was committed. (*Author's Collection*)

Left: Patrick O'Connor. (*Author's Collection*)

Wednesday evening, the eighth, when he came to dine with another friend, Pierce Walsh. He was expected the following evening but she insisted he had not come.

On 13 August, a work colleague, William Flynn, visited Patrick's lodgings at 21 Greenwood Street off Mile End Road, where he had lodged for the past five years with Ann Harmes. She was also concerned as she had not seen her lodger for four days. They went to his room and decided to open his strong box in which he was known to keep cash, his railway shares and other important documents. It was empty except for a number of IOUs as he also acted as a money lender. Ann revealed that Maria Manning, who possessed a key to his rooms, had called on the eighth and ninth and had stayed for two hours on both occasions. She also recalled a visit she made to see Patrick a few days earlier, when Ann had heard her apparently seeking his advice about investing in railway shares. On that occasion, Ann noticed that his own shares, cash and other documents had been removed from the strongbox and were spread out on the table.

William was now convinced that his friend had been the victim of foul play and approached the police with his suspicions. The police clearly considered there to be grounds for these fears and made a several visits to Miniver Place but failed to find the Mannings at home. On Friday 17 August, it was decided to force an entry into the house to make a thorough search of the premises. Constable Henry Barnes noticed that the flagstones on the floor of the kitchen seemed to have been disturbed recently. They were removed and the officers began to dig.

Gradually, the naked body of a man was revealed and surgeon Samuel Lockwood was called for and his first act was to remove a set of false teeth from the dead man's mouth. A post mortem was performed at 3 Miniver Place and all of the internal organs were found to be healthy. There was a small protuberance over the right eye, which Mr Lockwood discovered was due to a bullet, which was lodged there and which he removed. There were a large number of fractures to the back of the skull, clearly resulting from a savage beating. However, a blunt instrument had not been used given that these were incised wounds, which the surgeon believed had been caused by a sharp object such as a chisel or crow bar.

An attempt had been made to destroy the body by covering it with lime but there had been little decomposition and his friends were able to verify the body was that of Patrick O'Connor. Further confirmation was provided by dentist William Comely, who identified the false teeth as a set he had sold the victim.

The Mannings were of course prime suspects for the murder but there were no immediate arrests for the couple had disappeared. A neighbour, Mary Ann Schofield, who lived opposite the couple, had seen Maria leaving the house alone in a cab at three fifteen on the previous Monday afternoon, taking a large amount of luggage with her. Frederick had returned home two hours later and having failed to obtain a reply when he knocked on the door, he approached Mary, who told him of his wife's departure. This information led police to believe that Maria had double crossed her husband by leaving the district without first telling him and that she had probably taken the proceeds of the crime with her.

Their descriptions were circulated throughout the country as the police began to gather a great deal of circumstantial, but nevertheless incriminating, evidence against

O'Connor's body is discovered. (*Author's Collection*)

them. William Massey, a medical student who had lodged with the Mannings earlier in the year, revealed that he had several conversations with them concerning the deceased, who they said was worth £20,000. They had sought the student's advice about which drugs could be administered to make an individual so disorientated that he or she could be persuaded to sign a document, which they would not normally agree to do. They also asked him where the most vulnerable part of the human skull was located.

The police also discovered details of the rather unusual relationship the Mannings had with their alleged victim. Twenty-eight year old Maria was a Swiss national whose maiden name was de Roux. She had arrived in England three years earlier and entered domestic service. Shortly after doing so she met Manning and O'Connor and had a sexual relationship with both men. Both proposed but she decided to marry Manning, who was a former publican, then working on the railways. The ceremony took place in May 1847 but she continued to see the other man, apparently with her husband's knowledge and over the following two years the Mannings plotted to murder him and make off with as much of his wealth as possible.

Mary Wells and Richard Welsh who worked for a builder in Bermondsey advised police that the Mannings had ordered a quantity of lime, similar to that in which the body had been covered and which was delivered to 3 Miniver Place on 25 July. Their enquiries also led investigators to the premises of ironmonger William Cahill who had sold Mrs Manning a spade for 1s 3d on 8 August.

William Danby who was employed in a local general store recalled Frederick Manning ordering a crowbar for which he paid 3s 6d, which was to be delivered to his home on 28

Maria Manning is arrested. (*Author's Collection*)

The house in which Frederick Manning was arrested. (*Author's Collection*)

July. William met Manning as he made his way to Miniver Place to deliver the crowbar on that day and he had become extremely agitated when he saw that the crowbar was not wrapped. Manning complained that anyone could see what it was and he did not want his neighbours to know anything of his business. He insisted on visiting a stationer's shop where he purchased several sheets of brown paper in which to wrap it.

The police now believed that both of the Mannings were involved in planning the murder, the motive for which was robbery of their victim's valuable railway shares and the considerable amount of cash he kept in his strongbox. They also believed that they had intended to murder him on the evening of 8 August but were unable to do so as he was not alone when he arrived, for unexpectedly he had brought Pierce Walsh with him, resulting in the deed being postponed for twenty four hours.

Following the circulation of their descriptions, cab driver William Kirk came forward to say he had taken Maria to a railway station from which she could take trains to the north on the day she left Miniver Place. William Byford, another cab driver, informed police that he had taken her husband to a station at which he could take trains heading south, two days later.

Maria was arrested in Edinburgh on 21 August after she had attempted to sell the stolen railway shares, details of which had been published. She denied all knowledge of the murder and claimed the shares belonged to her. Frederick Manning was arrested six days later on Jersey, where he had been recognised. He immediately told Captain Chevalier, head of the island's police 'She shot him; she invited him to dinner; the cloth was laid when he came in; she asked him to go downstairs to wash his hands, and when at the bottom of the stairs she put one hand on his shoulder and shot him at the back of the head with the other'.

Despite the attempts of each to blame the other for the crime, both were convicted of the murder at their trial, at which the crown argued that she had shot him and he had finished him off by beating him about the head. Charles Dickens was in the crowd of fifty thousand who witnessed their executions and so appalled was he at the behaviour of many of the spectators that he wrote to *The Times* to lend his support to the campaign to end public executions and part of it read;

I believe that a sight so inconceivably awful as the wickedness and levity of the immense crowd collected at that execution this morning could be imagined by no man, and could be presented in no heathen land under the sun. The horrors of the gibbet and of the crime which brought the wretched murderers to it, faded in my mind before the atrocious bearing, looks and language of the assembled spectators. When I came upon the scene at midnight, the shrillness of the cries and howls that were raised from time to time, denoting that they came from a concourse of boys and girls already assembled in the best places, made my blood run cold. As the night went on, screeching and laughing and yelling in strong chorus of parodies on Negro melodies, with substitutions of "Mrs Manning" for "Susannah" and the like, were added to these. When the day dawned, thieves, low prostitutes, ruffians and vagabonds of every kind flocked on to the ground with every variety of offensive and foul behaviour. Fightings, faintings, whistlings, imitations of Punch, brutal jokes, tumultuous demonstrations of

The Mannings appear before the magistrates. (*Author's Collection*)

indecent delight when swooning women were dragged out of the crowd by the police with their dresses disordered, gave a new zest to the general entertainment. When the sun rose brightly – as it did – it gilded thousands upon thousands of upturned faces, so inexpressibly odious in their brutal mirth or callousness, that a man had cause to feel ashamed of the shape he wore, and to shrink from himself, as he fashioned in the image of the Devil. When the two miserable creatures who attracted all this ghastly sight about them were turned quivering into the air, there was no more emotion, no more pity, no more thought that two immortal souls had gone to judgement, no more restraint in any of the previous obscenities, than if the name of Christ had never been heard in this world, and there were no belief among men but that they perished like the beasts. I have seen habitually, some of the worst sources of general contamination and corruption in this country, and I think there are not many phases of London life that could surprise me. I am solemnly convinced that nothing that ingenuity could devise to be done in this city in the same compass of time, could work such ruin as one public execution and I stand astounded and appalled by the wickedness it exhibits.

One of the arguments put forward by opponents of public executions was the often appalling behaviour of the spectators which it was claimed brought the process into disrepute. This letter, written by one of the country's leading writers was an important contribution to the debate in the years to come.

1851

Levi Harwood and Samuel Jones were executed on 15 April for murdering the Reverend George Edward Hollest at Frimley on Saturday 28 September 1850.

THE EXECUTION OF
FRED. GEO. MANNING,
AND
MARIA, HIS WIFE.
At Horsemonger Lane, November 13th, 1849,
For the MURDER and Robbery of PATRICK O'CONNOR.

This morning the last act in the tragedy of the Mannings' was performed on the roof of Horsemonger Lane Gaol, in the presence of an immense assemblage.

The gardens in front of the houses opposite the prison, and from which the best view could be obtained, commanded high prices, and were occupied by persons of apparent respectability, and amongst them were many well-dressed females.

A few minutes before the clock struck nine, the bell of the prison chapel was heard to give forth the fatal toll, and those who had collected in the vicinity of the scaffold were observed to uncover, which was taken up by the populace below as a signal to do the same, and to call for silence. Immediately the roar of voices which had previously prevailed became hushed and still, and the mournful cavalcade ascended the steps of the scaffold, —Calcraft first, then the Chaplain, followed by the wretched man Manning, who ascended the stairs with a firm step, but appeared pale and emaciated. He was dressed in deep black, with a long frock-coat. The rope having been adjusted and the cap drawn over his face, Mrs. Manning, the female partner in his crime was brought up. She was dressed in black satin, tightly bound round the waist, with a long white collar fastened round her neck. On advancing up on the drop, and observing her husband at her side, as if acting upon the sudden impulse of the moment, she seized his right hand and shook it for several minutes. The hangman then hurriedly completed his deadly preparations, the next minute the slam of the drop was heard, and the dread sentence of the law had been accomplished. Manning gave a few convulsive jerks, and all was over, but his wife had a long struggle with death, and it was some moments before the immortal spirit had quitted her body for ever.

THE BERMONDSEY TRAGEDY.
BY J. CLARKE.

Come all you good people of every degree,
I pray you give attention and listen to me,
'Twas in the county of Somersetshire where I was bred and born,
And my wife she is a foreigner,—with her must die in scorn.

For the murder of O'Connor we are condemned to die ;
My wife she said I'm innocent of that sad tragedy,
But 'twas she who shot O'Connor and swore she would shoot me,
Unless I would assist her to bury his body.

Four months before his murder his doom was ready sealed,
His grave made ready under ground his body to receive,
He little thought his death so near when to the house he came,
But his death was plann'd all by our hands his money to obtain.

For murder and plunder they both were fully bent,
They shot him with a pistol, and to his lodgings went,
They got his cash and jewels and quickly did repair, [pair
To hide the guilt for the blood they'd spilt—oh! what a wretched

At the Old Bailey, London, the trial it came on,
They were arraigned before the judge and English jurymen,
The counsel for the prisoners they nobly did defend,
And tried to prove their innocence, this point they did contend.

After the trial, Mrs Manning said,
I do protest I'm innocent and been unfairly tried,
Though you've pronounced me guilty, and doom'd me to be hung,
More like a dog than Christian, to a being thus undone.

With rage and desperation the keepers by them stood,
And to their gloomy prison they quickly were removed,
The coolness and courage which they before displayed,
Had now forsook them for a time, and they look'd quite dismay'd.

This wicked woman taken was unto Horsemonger Gaol,
Her husband followed after, and very soon did feel
Contrition for his guilty deeds, and to his wife he wrote,
Begging of her to think how soon she was to meet her fate.

The end of poor O'Connor will long in memory reign,
And shew the vice and folly which followed in its train.
Oh! may it thus a warning prove to shun bad company,
Never like the Mannings commit such a tragedy.

Now in their gloomy prisons bound down in irons strong,
Awaiting for the fatal morn when they will meet their doom,
For the murder of O'Connor—oh! what a horrid crime,
Now they are both cut off in the height of their prime.

Stewart, Printer, Botchergate, Carlisle.

A broadside giving details of the Bermondsey Tragedy, sold at the execution of the Mannings. (*Author's Collection*)

Reverend Hollest had served as the vicar of Frimley for seventeen years and the popular fifty-four year old lived in the parsonage with his wife Caroline, who was fifty-one years of age, their groom and two maids. On Friday 27 September, their two teenage sons had arrived home from school to spend the weekend with their parents. By eleven o'clock that night all members of the household had retired to bed.

Four hours later, Mr and Mrs Hollest were awoken by intruders, wearing distinctive masks made of a green material, who had burst into their bedroom. Initially, the vicar thought they were his sons, playing a prank, and ordered them back to their room. However, his wife had immediately realised that there were three men and that they were armed. One was holding a pistol to her head and the other was holding a weapon to her husband's.

She screamed but the men demanded they be quiet or they would blow their brains out. Undaunted, Mrs Hollest climbed out of bed and tried unsuccessfully to pull the bell rope to alert the others in the rectory. However, the rope snapped and she was forced to the floor by one of the men, who put the pistol to her face. Her husband also struggled out of bed and attempted to grab hold of a poker but was shot in the abdomen as he

did so. The men ran from the bedroom, pursued by the vicar, who unaware that he was wounded, had taken his loaded gun from its drawer. He saw the three figures running through his garden and fired a shot at them before they disappeared into the night.

The servants and the boys had heard the shots and had left their beds. Mrs Hollest sent the groom, Richard Giles, to contact the police and to advise a local doctor to tend to her husband who was now in considerable pain. The police found that the burglars had gained entry by breaking a scullery window. They had then opened all of the internal doors and the front entrance to allow for a rapid escape if the need should arise.

The police were convinced that those responsible for the crime were professional criminals and this was reflected in the care they had taken in selecting the items to steal. Their booty included cash, three watches, two of which were gold, and a large selection of silver items such as a snuff box, pencil case and several knives. Half a mile from the scene of the crime the police discovered some part eaten bread and meat which had been taken from the parsonage, suggesting that far from being in a panic after the shooting they had coolly stopped to take some refreshments.

When Mr Davies, the family doctor, arrived he found the wounded man in a cheerful mood and fully conscious. Nevertheless, on examining the injury the doctor was not convinced that his patient and friend would survive. This prognosis proved to be correct, for the rector began to experience agonising pain throughout Saturday and by noon the following day it was clear that he could not be saved. His family decided that he should be told and he received the news with equanimity. Having bid farewell to family, friends and his distraught servants, all of whom had served him for many years, he forgave his killer. He died at eight twenty on Sunday evening. A post mortem revealed that the bullet had caused massive internal injuries.

The news of the murder caused outrage especially in the rural districts of the county where residents had long complained about the absence of effective policing. There had been a series of high profile burglaries in the recent past within a ten mile radius which included the homes of Major Birch of Clare Park and Mr Stovold of Runfold, both near Farnham, Mr Lindsay of Hampton Lodge, Lady Wyndham of Sutton near Guildford and Mr Tickill of Frimley Grove. It was therefore decided to offer a reward for the capture of those responsible for the murder of Reverend Hollest, as the same gang was thought to have been responsible for all these crimes. It read as follows;

BURGLARY AND MURDER – £100 REWARD

The dwelling house of the Rev. George Edward Hollest, at Frimley-grove, Surrey, having been burglariously entered by several men on the night of the 27th of September 1850, when one of them shot and wounded Mr Hollest, of which wound he died on the 29th, a reward of £100 will be paid by Her Majesty's Government, and a further reward of £50 on behalf of the disconsolate widow, to any person who shall give such information and evidence as shall lead to the discovery and conviction of the burglars. And Her Majesty's gracious pardon will be granted to any accomplice (not being the person who actually fired the shot) who shall give such information and evidence shall lead to the same result.

However, the police had already detained a number of suspects, one of whom was professional thief, Richard Trower, who was also known as Hiram Smith, by which name he was referred to by the authorities throughout this case. He had been seen close to the crime scene a few days before the murder and ironically, he had spoken with the local police officer, Constable Macey, who was unaware of his identity at the time. Smith was posing as a pedlar in crockery and had told the constable that he had sold two plates to the rector for 3*d*. Those investigating the crime were convinced that Smith was in the vicinity to reconnoitre the premises in advance of the burglary. Smith was believed to be a leading member of the gang and on the evening of Sunday 29 September he was arrested at the Rose and Crown beer shop in Guildford with two companions, Levi Harwood and James Jones. The three men denied any involvement in the crime and insisted that they had not been in each other's company on the night of the murder.

Smith insisted that on the Friday afternoon he had been in Kingston, where he had hoped to find employment as he had heard that men were wanted to lay water pipes in the town. On failing to do so, he travelled to London and that night had visited the Surrey Theatre. Harwood claimed he left Guildford at five o'clock on Friday evening and had walked as far as Ripley. From there he was given a lift in a cart and reached Vauxhall at midnight. He had spent a few hours in a coffee shop and at eight o'clock on Saturday morning had been on London Bridge looking for work. Jones stated that from Friday evening through to the early hours of Saturday, he was on the Downs near Guildford, watching the snares he had set to catch rabbits.

However, nobody was produced to corroborate the accounts of their movements and the case against them was strengthened by the statement given by Mary Gouldstone, a nursemaid in the home of Frimley resident Mr Mayberry. On the night of the crime she had been unable to sleep and at midnight had looked out of her bedroom window from which she saw three men standing on the road outside. They were strangers and she later identified them as the three suspects being held by the police.

Following their arrests, the police obtained warrants allowing them to search the homes of the men and their known associates. At the home of Samuel Harwood, cousin of Levi, green cloth similar to that from which the masks had been made, was found. At the house Levi Harwood shared with Mary Ann Croucher, several items believed to be part of the proceeds of a recent robbery at Chichester were discovered. This did not assist the police in their investigation into the Frimley murder, but it did add weight to their belief that the three men being held were part of a major criminal gang, responsible for many crimes throughout Surrey and the South East of England.

The use of trace evidence based on scientific analysis was in its infancy, but the police measured the feet of the three men to compare with the footprints found outside the rectory and they were identical. It was believed that the burglars had been in their bare feet at the time of the crime and Harwood's right big toe was badly cut which was thought to have been caused as he ran from the scene.

As the evidence against the men continued to be gathered, Smith asked for an interview with Mr Keene the governor of Guildford Gaol in which he was being held. He offered to turn Queen's Evidence and provided a written statement. In it he admitted

he had planned the crime with those also held in custody and that the fatal shot was fired by Levi Harwood, but claimed that the guns had been taken only to frighten their victims and not to use against them. Following the break-in they made for Kingston where the others waited while Harwood took the proceeds to London to sell. Smith's share of the crime was 7s 6d.

With the executions of Harwood and Jones and the arrests of their associates for other crimes, it was believed that a major gang of desperate criminals had been broken up.

1852

John Keene was hanged on 13 April for the murder of Charles Broomer on or about 9 February 1851 at Albury.

In May 1848, Jane Broomer gave birth to an illegitimate child she named Charles and with the support of her family she was determined to keep him. For three months after the birth she stayed with her mother Ann at her home in Albury but then decided to enter the workhouse at Guildford. This proved to be a temporary arrangement for after several months she found work as a domestic servant and paid a child minder to take care of her son. This arrangement lasted until Jane met and married John Keene, whereupon Charles returned to the care of Jane and her new husband. In December 1850 she gave birth to another son, of whom Keene was the father.

Keene depended upon casual employment as a labourer to support his family and on 10 January 1851 he, his wife and the two children entered the workhouse as he was unable to find work. A few weeks later, on 6 February they left the institution and for the next three nights they lodged with Jane Barefoot in Guildford. On the night of 9 February, Jane stayed with a friend, Hannah Ranger, but only had the younger child with her. Hannah knew Charles and when she asked after him, Jane said he was in London. Charles would never be seen alive again and when friends and relatives enquired after him his mother always replied that he had died in the capital.

However, in January 1852, Jane shocked her mother by telling her that Charles had been murdered by her husband, the previous February. He had told her that if she ever informed on him he would kill her but her conscience would no longer allow her to remain silent. She added that the child's body was at the bottom of the Warren Well on Albury Heath. Her husband had beaten him with a heavy stick and she had watched helplessly as the child was picked up and hurled into the well. She heard the splash as he hit the water and despite her pleas, Keene made no attempt to rescue him. She refused to accompany him to their lodgings in Guildford and had walked to her mother's home, since when she had remained silent.

Jane's mother advised Reverend Hooper, the local vicar, who in turn told the police of what Jane had said. Superintendent Josiah Radley of the Guildford police visited the Keenes at their lodgings. Jane was alone and when asked if she knew the reason for his visit she replied 'Yes, you have come about my child. Oh, Mr Radley, my husband has murdered him, and I hope he will confess all'. Later, when he arrested Keene on suspicion of committing the murder, he insisted Charles had died twelve months earlier

in London, but could give no specific details. He later told the superintendent 'She may say that I drowned the child, but I never put it in no water'.

The police enlisted the help of well digger William Edsor, who, over a period of several days at the end of January descended into the one hundred and fifty foot well on a number of occasions. He found the badly decomposed body of a child and although several limbs had become detached from the trunk, he reported that he thought the child had died sat up against the wall, which suggested he or she had been alive when it reached the bottom of the well. Several items of children's clothing were also found.

Guildford surgeon Mr T. J. Sells was given the task of performing a post mortem on the still as yet unidentified body. Little flesh remained and he reconstructed the skeleton which was complete. From its size and after examining the twenty teeth that were found, he concluded that the body was that of a male child about three or four years of age. The items of clothing were identified by friends of Jane as being similar to those worn by her son and at the inquest the body was formally identified as being that of Charles. Given the information provided by Jane Barefoot and Hannah Ranger, the police were convinced that the murder had occurred on 9 February.

On 25 March 1852, John Keene who was now twenty years of age and Jane, five years his senior, stood trial for the murder of Charles and each was represented by a different barrister. Jane kept to her version of events, insisting he was solely responsible for the crime and the reason she had remained silent for so long was fear for the safety of her and her surviving child. The motive for the crime stemmed from his lack of feelings for his stepson, which led Keene to decide he did not want the burden of supporting him. His barrister argued that the jury should not rely on Jane's uncorroborated testimony as a basis for sending his client to the gallows, for she had much to gain by lying about her lack of involvement in her son's death.

Following a brief retirement, the jury found Keene guilty and his wife innocent. From the moment of his conviction until his execution before a hostile crowd of several thousand, he maintained his innocence, insisting his wife had committed the murder.

1860

On 4 September, William Godfrey Youngman was hanged for the murder of Mary Wells Streeter at Walworth on 31 July. There were three other victims, his mother Elizabeth, and his brothers Charles and Thomas aged eleven and seven respectively. However, these cases were not proceeded with following his conviction for the first crime.

Three families lived at 16 Manor Place, Walworth, which was owned by James Bevan who occupied the ground floor. Philip Beard and his wife Susannah lived on the middle floor and tailor John Youngman, his wife and two youngest sons had rooms on the top floor. In mid-July 1860, his eldest son, twenty-five year old William, who brought his fiancée, Mary Streeter, had come to stay temporarily.

At five thirty on the morning of 31 July, John Youngman left for work. Twenty minutes later Mr Bevan and the Beards heard loud noises coming from the top floor of the house. On opening his door to investigate, Mr Bevan heard an agitated Mr Beard call to him 'For

God's sake come here, there's been a murder'. The two men rushed up the stairs and as they did so were passed by William. Mrs Beard emerged from her door and William, who was saturated in blood, said 'Mrs Beard, my mother has done all this. She has murdered my sweetheart and my two little brothers, and I believe, in self-defence, I have murdered her'.

On reaching the top floor the two men encountered a scene of total horror. There were three bodies on the landing, those of Thomas, his mother and Mary. Thomas was lying on his back, his right arm drawn up slightly. Mary's head was in the doorway and she was lying on her right side. The older woman's body was face down and the scene was drenched with fresh blood which was flowing along the floor. Charles was lying on his bed, the sheets of which were saturated with his blood.

Surgeon, Mr W. B. Boddy arrived but he could do nothing for the victims who were all dead. Mary had been stabbed in her left breast and her throat had been cut. Her carotid artery and jugular vein had been severed and the bones of her neck were exposed. Elizabeth had suffered three stab wounds, two of these being to her left arm and another to her breast; she too had suffered a similar throat wound to that of Mary. Charles had been stabbed twice in the arm and once to the chest; a wound to the back of his neck had severed his spinal cord. Thomas had been stabbed twice in the chest, his lower lip was badly cut and there were seven other wounds to various parts of his body. A knife which was found at the scene was identified as the murder weapon.

When questioned by Inspector James Dann of P Division, Youngman insisted that his mother had been responsible for the morning's events. He had woken up to find her at the side of the bed in which he and Thomas were sleeping. She was stabbing his brother repeatedly but he managed to grab the knife from her and in self-defence was forced to kill her with it. He had staggered on to the landing where he discovered the bodies of those she must have murdered beforehand.

The police were not convinced by his version of events, believing him to have been responsible for the deaths. These suspicions were confirmed when they learnt that on 16 July he had left his job as footman to Dr Duncan of Henrietta Street, Covent Garden and three days later had accompanied Mary to the offices of the Argus Insurance Company. There, he had taken out an insurance policy on her life for £100, in which he was named as sole beneficiary. An initial instalment of 10s 6d was paid by Mary before the couple left the premises.

He persisted with his claim that his mother had killed the three others and he had been forced to kill her afterwards. However, at the trial the jury took just ten minutes to convict him, believing him to have slaughtered those who loved and trusted him for financial gain, intending that his mother would be held responsible.

1864

On 12 January Samuel Wright was hanged for the murder of Maria Green at Lambeth on Sunday 13 December 1863.

Samuel Wright, a thirty year old bricklayer, and Maria Green, a woman ten years his senior, had been living with each other for twelve months, for the last three of which

LIFE, TRIAL, AND EXECUTION OF
WILLIAM G. YOUNGMAN,
The Walworth Murderer.

On Thursday, August 16th, William Godfrey Youngman was placed at the bar of the Central Criminal Court to take his trial for the murder of his mother, two brothers, and his sweetheart.—Shortly after ten o'clock the learned judge, Mr Justice Wilhams, took his seat on the bench. The prisoner, who was described as a tailor, and 25 years of age, was then placed at the bar. He exhibited perfect coolness and self-possession, and did not seem in the slightest degree affected at his awful position. The indictment that was proceeded with was the one charging him with the wilful murder of his sweetheart, Mary Wells Streeter.—Mr James Bevan said : I reside at 16, Manor place, Walworth. The prisoner's father occupied the top floor of the house. On the 31st of July his family consisted of his wife, two little boys, the prisoner, and the deceased. I understand the prisoner had come to see his father on a holiday, and he would sleep there. About ten minutes to 6 in the morning I was in bed, and heard a noise and a heavy fall on the top floor of the house. I got up to see what was the matter, and before I could get to the door Mr Beard knocked at it and said, " For God's sake come here—here is murder." I went upstairs directly, and when I got to the top of the stairs I saw the elder boy lying dead upon the landing, I did not see anything more then, but went down and dressed myself, and I then saw the prisoner standing in his nightshirt on the staircase. He said to me " My mother has done all this—she murdered my two brothers and my sweetheart, and I, in self-defence, believe I have murdered her." I went out and fetched the police.—Susannah Beard said : Me and my husband occupied the back room as a sleeping room. About one o'clock in the morning of the 31st of July, I heard a noise overhead like something very heavy falling on the boards of the bedroom above ours. My husband went out to see what was the matter, and he called out "Murder !" and came downstairs. He afterwards went up again with the landlord. I went to the door of our room and saw the prisoner standing on the staircase. He said, Mrs. Beard, my mother has done all this. She has murdered my sweetheart and my two little brothers, and I believe in self-defence I have murdered her."

Philip Beard, the husband of the last witness, said, I had seen the prisoner in our house a few days. I remember being awoke by my wife, and I heard a rambling on the landing. The noise was like that of children running about. I went out of my room, and I heard a slight scream. When I got to the outside of my room, I saw some blood on the stairs, and on the top of the staircase I saw the little boy lying on the landing. His throat was cut and he was dead. I then saw the body of the deceased lying a little beyond that of the boy. I did not observe any other bodies at the time, as I was very much alarmed, and I went down and called the landlord, and we went upstairs together ; and I went to dress. I then fetched a policeman and a surgeon. I saw the prisoner upon the stairs, and he

told me that his mother had done it all, and that he had murdered her in self-defence.

After the further examination of a number of witnesses, who corroborated the evidence already given, Mr. Best, in a powerful and touching speech, addressed the jury for the prisoner.

The jury retired, and in about 25 minutes returned into court, and amid breathless suspense gave a verdict of Guilty.

The judge then put on the black cap, and delivered the following sentence : Prisoner at the bar, you have been convicted of the crime of murder, and one of the most heinous ever committed, but it is no part of my office to dwell on the enormity of your guilt. It is my only duty to pass upon the sentence of the law, and that sentence is—That you be taken to the prison from whence you came, and then to the place of execution, and there be hanged by the neck until you are dead. May the Lord have mercy on your miserable soul !

EXECUTION.

Tuesday, September 4th, was the day appointed for the execution of Youngman, the perpetrator of four murders at Walworth. At an early hour people of the lowest order began to assemble in the neighbourhood of the prison, and by five o'clock every available space was occupied. At seven o'clock the chaplain entered the condemned cell to administer religious consolation to the criminal, and remained with him until the time of his execution. In reply to exhortations addressed to him by the chaplain, he repeated substantially the story he had always told as to his share in the crime. The chaplain urged him not to leave the world with a lie in his mouth. " Well, if I wanted to tell a lie it would be to say that I did it." He, nevertheless, conducted himself towards the chaplain with respect, listened to him with attention, and joined in prayer ; but, beyond those mechanical observances, he showed no evidence whatever of feeling.

The minutes which remained to him to live might now be numbered. He was then conducted to a gateway ; in which a corridor he had to traverse terminated, and there, a few minutes before nine, he was pinioned. The procession then formed, the gates were opened, the chaplain commenced reading the burial service, and, so escorted, the convict proceeded to the beam. On arriving at the drop and confronting the mass of human beings he looked wild and startled, but, recovering his composure he allowed himself to be placed on the drop, and, with evident fervency and an audible voice, he followed the chaplain in a prayer, clasping his hands in unmismakeable devotion. For a moment he paused to request the executioner, who was adjusting the noose, to pinion his legs, which was done ; and his parting words addressed to the chaplain—were, " Thank you, Mr. Jessop, for your great kindness ; see my brother, and take my love to him and all at home."

The drop fell, and he died in a few minutes.

H. Disley, Printer, 57, High Street, New Oxford Street.

Despite attempting to place responsibility on his mother for the killings, William Youngman paid the ultimate penalty for his dreadful crimes. (*Author's Collection*)

they had lodged at 11 Waterloo Road. This was the home of Mrs Redbourne and there were several other lodgers in the property. The landlady had found them to be a quiet and respectable couple who gave her no cause for concern. That was until the early hours of Sunday 13 December 1863, when following a night's drinking at the nearby Feathers public house, their raised voices were heard by the other tenants in the house.

Hannah Ryland left her room and met Wright on the stairs. There was blood on his arms and she asked what had happened, to which he replied 'Go and see'. Hannah pushed the door to their room open and saw Maria on her hands and knees, who said in a hoarse whisper 'He has cut my throat'. Frightened for her own safety, Hannah ran to her room and locked the door but left it to join Mrs Redbourne on the landing. Two police officers arrived and they and the two women returned to Wright's room. He was there and he grabbed Hannah's hand saying 'Do break it as quietly as you can to my old woman', meaning his mother. An open razor was on the table and a poker lay on the floor, both of which were covered in blood. Without any prompting, Wright told one of the officers 'I have done it, and it can't be helped'. He sat down and made no attempt to escape, adding that she had threatened him with a knife during their argument.

A doctor, George Harrop arrived by which time Maria was dead. There were signs of a beating and the poker was probably used to inflict those injuries. There were also two wounds to her neck, either of which could have been the fatal injury. That on the left side was nine inches long and the jugular vein and carotid artery had been damaged. The one to the right was five inches long and had severed the jugular and damaged the windpipe. This information was provided the following day when Wright appeared before the magistrates and at the inquest, held at the Feathers on the day after that.

Three days after the crime had been committed, on Wednesday 16 December, Wright appeared before Mr Justice Blackburn at the Old Bailey. When the charge was read out to him, he replied 'Guilty'. This prompted the judge to ask him if he understood completely the consequences of such a plea, emphasising that he would be admitting to a murder for which no excuse could be offered. Wright insisted that he was fully aware of his position. It was at this stage that Mr Sleigh, the crown's barrister rose to his feet and he too suggested that the accused should reconsider as he had only just been committed to stand trial, was not represented and had not yet had the benefit of legal advice. Nevertheless, Wright insisted that he wished to proceed and he was duly sentenced to death. This meant that the murder was committed, the magistrates' hearing, inquest and trial held, all within a period of four days, and before the victim had been buried.

Over the following days, the case became something of a *cause célèbre* as support for a reprieve quickly gathered momentum. A petition signed by 2,543 supporters and another signed by six hundred Lambeth tradesmen were submitted to the Home Office together with a letter signed by all the visiting magistrates to Horsemonger Lane Gaol, where he was being held.

Wright too, seems to have reconsidered his situation and sought a reprieve. A woman, with whom he and Maria had been drinking on the Saturday night, supported

his claim that his victim had hit him during the evening. He also described intense feelings of jealousy after she indicated she was thinking of leaving him. He also raised the issue of her threat to stab him after they had returned to their lodgings, although he accepted he had not seen a knife in her hand. Maria was now being portrayed as a disreputable woman, who had provoked her killer both physically and emotionally.

It is of note that in the first sixty-three years of the nineteenth century in Surrey, Yeoman was hanged for the murder of his fiancée, but that was part of a wider crime for financial gain, and Jardine was executed for attempting to poison his wife. Only one man was hanged for murdering his wife, either by marriage or in common law and that was Stillwell in 1803. That there were so few executions for this category of murder does not mean the crime was rare, but that the charge was often reduced to manslaughter on the grounds of provocation. This practice was a manifestation of the subservient position of women in the early nineteenth century, when they were perceived as being little more than the property of men. Women killed by their husbands were usually portrayed as being sexually promiscuous and unfit wives and mothers if they drank to excess, threatened to leave the man or had an affair.

That is why the following comprehensive reply from the Home Office to the visiting justices is such an important document, as it heralds a sea change in how such domestic murders would henceforth be dealt with by the courts. The woman's position within a marriage and in the wider society was improving, albeit slowly, and this would be reflected in the way men responsible for killing women with whom they were in a relationship would be dealt with. It also accounted for the increase in the number of men who would be hanged and why in the remaining twenty-six years of the century seventeen men would hang for the murder of a woman to whom they were legally married, cohabited with or with whom they were in some form of intimate relationship.

Whitehall, January 7.

Gentlemen, I am directed by Secretary Sir George Grey to acknowledge the receipt of your memorial on behalf of Samuel Wright, now under sentence of death for murder.

In reply, I am to acquaint you that having referred the petition addressed to him by the prisoner, together with his own statement, and other documents relating to the case, to the learned judge before whom the prisoner was arraigned, Sir George Grey has been informed by him that he believes the prisoner to have perfectly understood what he was doing when he pleaded 'Guilty', and that in his opinion the result must have been the same had he stood on trial, unless the jury neglected to do their duty. He further thinks that even if the statement since made by the prisoner could have been heard by the jury it would not have justified them in returning a verdict of manslaughter, though assuming its truth, it deprives the crime of the character of being a cold-blooded and deliberate murder.

The judge, moreover, while giving no opinion as to whether, under the circumstances, the sentence of the law should be executed or not, adverts to the fact that there was

nothing tending to show that there had been any violence on the part of the woman, except the prisoner's expression when apprehended (not as stated in the memorial that she had threatened to run a knife into him), but 'that is the knife she took up to me', meaning a knife found by the policemen on the table; and he adds that if there had been any such struggle as would in point of law have sufficed to reduce the crime to manslaughter, he should have expected that there would have been traces of it on the prisoner's clothes and person, and that the noise would have been heard.

Sir George Grey has no reason to doubt the alleged fact that the woman was a violent woman and of very bad character, but he can find nothing in the various declarations and documents which have been sent to him which alters the view of the case taken by the learned judge. Two persons, indeed, in describing what took place at the Feathers Tavern, say that on the prisoner coming to the tavern and calling for a glass of ale the woman began quarrelling with him and struck him twice, and one of them adding 'that he appeared to take it all in good part'. Even on the supposition that this is true, it is clear that the blows said to have been struck by the woman were not such as to cause provocation sufficient to reduce the crime committed in another place an hour afterwards from murder to manslaughter; but the statements themselves are not borne out by the prisoner's own statement, in which nothing is said of these alleged blows, or of any provocation until the woman woke him, and said she would run a bit of cold steel into him; but whether or not she had a knife in her hand he could not say. They then, according to his statement, had more words, and a scuffle ensued, when he snatched up the razor and cut her throat.

Under these circumstances, however painful it is to see a man of hitherto good character under sentence of death for such a crime, Sir George Grey regrets that he cannot feel justified in assuming, contrary to the opinion of the learned judge and to the facts as they appear from the depositions and the various documents before him, either that the prisoner did not know what he was doing, and the consequences of it when he pleaded guilty, or that if he had pleaded 'Not Guilty' and the trial had taken place, the verdict could have been any other than that of wilful murder.

It is one of those sad cases, unfortunately only too frequent, in which, without any cold-blooded or deliberate premeditation, life is taken under the influence of ungoverned passions, but with a full intention at the time, as evidenced by the use of a deadly weapon, and the nature of the injury inflicted, to take life, and without such provocation as could reduce the crime to manslaughter.

To commute the sentence on the grounds on which it has been pressed would, in fact, be to lay down a rule of law as to the distinction between murder and manslaughter contrary to that which is well established, and which, in the opinion of the learned judge, is applicable to the present case.

It is therefore with much regret that Sir George Grey feels he would not be justified in acceding to the prayer of your memorial.

I am, Gentlemen, your obedient servant,

H. Waddington.

When the contents of the letter became known a meeting was quickly organised by sympathisers who decided to approach Queen Victoria in the hope of gaining a reprieve. A deputation that included Mr F. Doulton, Member of Parliament for Lambeth, travelled by train to Windsor, where they met with the Queen's Private Secretary, Sir Charles Phipps. However, they failed in their efforts and when this was reported back to a public meeting, attended by three thousand at Lambeth Baths that evening, it was decided to approach the Home Secretary, who agreed to see the deputation late that night. However, he refused to change his mind and the meeting was informed at eleven o'clock that night, ten hours before the execution was due to take place.

The efforts to save Wright having failed, a handbill, trimmed in black in the form of a mourning card, was circulated throughout the neighbourhood of Horsemonger Lane in the hours preceding the execution which read as follows;

A Solemn protest against the Execution of Wright

Men and women of London, abstain from witnessing this sad spectacle of injustice. Let Calcraft and Co. do their work this time with none but the eye of Heaven to look upon their crime. Let all window shutters be up and window blinds be down for an hour on Tuesday morning in Southwark. Englishmen, shall Wright be hung? If so there is one law for the rich and another for the poor!

Wright was made aware of the unsuccessful efforts made to save his life and he asked that his thanks be passed on to his supporters. When he appeared on the roof of Horsemonger Lane Gaol there were cries of 'Shame' and 'This is judicial murder'. He died bravely but not before bowing several times to the crowd in appreciation for their support.

1867

James Longhurst was executed on 16 April for the murder of Harriet Sax at Shere on Thursday 28 June 1866.

It was a pleasant summer evening in late June 1866 and seven year old Harriet Sax was walking home to the village of Shere. Walking in the opposite direction was twenty-one year old James Longhurst, who without warning grabbed the little girl and dragged her into a nearby wheat field. Her cries were heard by two passers-by, who ran to her aid.

They found her bleeding from a deep throat wound but she was conscious and able to speak. Longhurst was seen attempting to hide in the wheat and licking blood from his hand. He was detained and the knife he had used was discovered in his pocket. When she saw him, Harriet said he was the one who had attacked and cut her.

She was losing consciousness and the grip on Longhurst had to be loosened so she could be helped. He ran off across the wheat field, but was soon recaptured by the police, who had by now arrived at the scene. Harriet was drifting in and out of consciousness but when he was brought back she immediately cried out 'That boy did it'.

She was taken to hospital in Guildford where she lingered for several hours before she died of her injuries. The wound to her throat was so deep that that the blade of the knife had penetrated the back of her neck, damaging the spinal cord as it did so. Her tongue had also been cut and it was thought this was done deliberately in an attempt to prevent her from crying out. There were a number of wounds to her face and the injuries to her arms and shoulders were consistent with her having been grabbed violently and dragged for some distance.

There was no immediately obvious motive for the crime and if it had been sexual, he did not have time to carry out any such assault before being disturbed. He appeared at the Surrey Summer Assizes at which his barrister asked for the case to be adjourned until the following March so that he could complete his enquiries into the question of his client's sanity. This was agreed to but when he next appeared the following spring, the issue of his sanity was not raised in his defence. That he killed Harriet was not denied but it was argued that the charge should be reduced to manslaughter as she was stabbed accidentally because she struggled with her attacker.

In his summing up the judge, Mr Baron Bramwell, poured scorn on this proposition which he felt was simply absurd. His barrister had also suggested that the jury might be reluctant to send a man to the gallows solely on the identification provided by a confused and dying seven year old. However, the judge pointed out that the crown case did not depend on her death bed deposition alone. Longhurst was arrested at the scene; he did not initially deny the offence; and there was blood on his hands and knife. Singly, these did not provide conclusive proof but the jury members could view them as a whole and draw their own conclusions.

The jury was absent for an hour before returning with a guilty verdict to wilful murder, but also with a recommendation for mercy as they believed it was not a premeditated crime. However, this was ignored by the authorities and all attempts to save him failed. Two days before his execution he said his final farewell to his mother, who clung to her son so desperately that she had to be prised away from him, and as she left he begged her to save him.

On the morning of his execution, his nerve gave way and on seeing the executioner he began to struggle violently to prevent his arms from being pinioned. Five warders were required to subdue him and escort him to the roof of the gaol. When he saw the scaffold he again began to struggle and cry out begging for mercy. He had to be held by the warders on the drop until the lever was eventually pulled.

*

On 15 October Louis Bourdier became the last person to be publicly executed in the county for the murder of Mary Ann Snow on Tuesday 3 September 1867 at Camberwell.

Thirty year old Louis Bourdier was employed in the leather trade as a currier and for the previous thirteen years he had been living with thirty year old Marry Ann Snow. They had three daughters aged twelve and ten years and a baby aged eighteen months. The family had lodged with Mary's cousin Caroline Snow at 3 Milstead Terrace in Camberwell for

HOUSE IN MILSTEAD TERRACE PORTRAIT OF THE PRISONER. THE MURDER OF EMMA SNOW.
THE TRAGEDY IN THE OLD KENT ROAD.

The murder of Mary Snow. (*Illustrated Police News*)

twelve months. Mary had told her cousin that she intended leaving the house and Bourdier on Tuesday 3 September 1867 but had not yet told him. She gave no specific reason but Caroline believed that Mary had formed a relationship with another man.

On the evening before she was due to leave, Mary and Bourdier called at a local inn, where they remained for some time before returning to their lodgings at about eleven o'clock. Those who had seen them later reported that they had seemed in good spirits and happy in each other's company. However, a little before six o'clock the following morning, Mary burst into her cousin's bedroom, clutching at a throat wound and crying out 'Look what Bourdier has done'. Caroline sent her daughter to find a policeman and doctor. A few minutes later, Bourdier entered the room and said 'I couldn't help it; I couldn't think of leaving her'.

When Constable Frederick Barrett arrived he found Bourdier standing over Mary who was now lying on the bed, his right hand on her forehead and his left hand on her breast. He immediately informed the constable that he was responsible and before being taken to another room, he leant forward and kissed Mary. He had written two letters, both dated 1 September, which he handed to the officer, one being addressed to his brother in France and the other was intended for Caroline. He sat down and calmly lit his pipe as he waited to be taken to the police station.

In the letters he described suffering poor health for the past eight months and experiencing a great deal of pain; he had recently been discharged from hospital having

spent six weeks receiving in-patient treatment. He wrote that he could no longer bear the pain and within the past fortnight had decided to kill himself, his wife and children. There was no mention of his wife possibly leaving him.

His nine year old daughter, Celestine, told police that she was woken by her mother's screams and very soon afterwards, her father had entered the bedroom in which the three girls were sleeping in one bed. He pushed Celestine's head back and told her to lie still. His other hand was behind his back, but she thought she saw the handle of a knife in it. She did not move nor did she speak to her father, who held her in this position for a minute. Without saying a word he released his grip, stood up and left the room, apparently unable to proceed with his plan to kill the children.

By the time surgeon George Simpson of the Old Kent Road arrived at six fifteen, Mary was on the point of death and there was nothing he could do to save her. He found the fatal wound to be six inches long, and her windpipe, veins and arteries to have been severed. Mr Simpson had worked extensively with men and women suffering from serious mental health problems and he was interested to learn from Bourdier what had occurred.

He introduced himself to the suspect and asked Bourdier for his version of events. Bourdier took a knife from his pocket and said 'That is the knife, you know, I bought home on Saturday on purpose to do it with'. He rose to his feet and agreed to describe how he did it; 'I got up about four o'clock, but my wife awoke and requested me to come to bed again, it being so early. I did so and waited a little time until she fell asleep again. I then rose cautiously, stood in front of her, kissed her, shook her hand and drew the knife across her throat. Then the blood came'.

His wife had then struggled towards the door to the room in which the children were sleeping, as if she realised they too were under threat. However, he prevented her from doing so by standing in front of the door and instead she went to her cousin's room. He continued by telling the doctor 'I intended cutting my own throat, but the blood prevented me'. When asked for an explanation he said 'It stood up like a pillar or barrier between the knife and my throat'.

Dr Simpson was convinced that Bourdier was insane at the time the crime was committed, which presented the prosecution with a problem for he was a crown witness, having performed the post-mortem. At the trial he insisted that a physical illness could lead to mental health difficulties and referring specifically to the accused's medical history he told the court 'Fistula was of a decidedly depressive nature, as was also the system which generated it. The disease was the result of general disorganisation of the system, the tubercular system. Some diseases had a more depressing effect on the mental condition than others. Fistula was one'.

The crown, however, refused to accept that the accused was insane, describing the crime as a premeditated murder as evidenced by the letters written beforehand and his using a knife from his workplace. A number of witnesses were called to contradict the testimony of Mr Simpson. Bourdier had spent part of his time on remand in both Newgate and Horsemonger Lane Gaols, the surgeons and governors of both being called to testify that they had seen no evidence of insanity. The jury decided he was not insane and should pay the full penalty.

1870

On 11 October Margaret Waters was executed for the murder of John Walter Cowen in the summer of that year in Brixton. She was the first person to be hanged in Surrey within the prison walls as public executions had been abolished in 1868.

On the night of 28 May 1870, Police Sergeant Richard Relf noticed a pale looking girl leaving the house of midwife Harriet Castle. He thought she looked as though she might have given birth very recently but she was not carrying a child. She was put in a four wheel chaise, which he was able to follow to Loughborough Villas in North Brixton. He subsequently learnt that the girl was Jeanette Tassey Cowen, the sixteen year old single daughter of teacher Robert Cowen. The sergeant later visited Jeanette and the midwife who told him a baby boy, given the name John Walter Cowen, had been born but had immediately been placed for adoption. However, neither of them knew the present whereabouts of the child. Jeanette's father had replied to an advertisement in the *Lloyd's Weekly Newspaper,* which had read as follows;

> Adoption – A good home, with a mother's love and care is offered to any respectable person wishing her child to be entirely adopted. Premium, £5, which sum includes everything. Apply by letter only to Mrs Oliver, Post office, Grove Place, Brixton.

There was by the latter part of the nineteenth century, a growing awareness of the activities of baby farmers. These were women who would offer to take a child from a usually desperate single woman, who did not have the support of the child's father, promising to place it for adoption. A fee was asked for, but in the worst cases, the children were either murdered immediately or allowed to die slowly of starvation, thus enabling the baby farmer to pocket the money. Sergeant Relf was determined to ensure that this was not such a case but he was pessimistic when he learnt that the baby had been handed over in a public place, away from the address where the baby would be taken so that the mother could not later make a visit should she wish to see her child again.

The sergeant replied to the advertisement, pretending to have a child he wished to have adopted and received the following reply;

> Wednesday, June 8 – Sir – In reply to your letter, I beg to say that it would give me great pleasure to adopt as my own your little boy, if he is not too old. You omitted to state the child's age and I wish for one as young as possible that it may know none but ourselves as its parents. The child would be well brought up and carefully educated; he would have a good trade and be to us in all respects as our own. We have been married several years but have no family. We are in a comfortable position, have a good business and a home in every way calculated to make a child happy. We are both very fond of children and should you entrust your little one to my care you may rely upon his receiving the love and care of a mother. Any place you like to appoint for an interview will suit me. I can meet you at any time you please, and should be very glad to have the matter settled as soon as possible. Hoping to have an early reply, I am Sir, respectfully yours, R. OLIVER.

The neglected babies are discovered. (*Illustrated Police News*)

BABY FARMING AT BRIXTON

A meeting was arranged with Mrs Oliver at Camberwell New Road Station and they discussed the possible adoption of the officer's non-existent child. She again emphasised that the child should preferably be very young, which raised his suspicions as those with malevolent intentions wanted such children as they could not resist nor attempt to flee and were thus easier to dispose of.

At the end of their interview, the sergeant followed the woman to 4 Frederick Terrace in Brixton, which he discovered had been rented to a Mrs Wallis. The next day, Sergeant Relf called at the house with Jeanette's father, Robert Cowen. The door was opened by the woman who had passed herself off as Mrs Oliver but who was in fact twenty-nine year old Sarah Ellis. She initially denied any knowledge of Mrs Wallis or Jeanette's baby and insisted she was not involved in adopting children. The officer persisted until she called out 'Mary, bring up Miss Cowen's child'.

The woman going by the name of Wallis was thirty-five year old Margaret Waters, sister of Sarah. Robert identified her as the woman he had met to agree terms for adopting his grandson and he became greatly distressed when he saw the appalling state he was in after being in the care of the two women for the past fortnight. He was emaciated and seemed close to death. His grandfather accused the sisters of being murderers but they insisted they had only just realised the child was ill and were about to call for a doctor.

Sergeant Relph demanded to be let in to the house and what he and Mr Cowen found in the dark and squalid interior would lead to one of the most appalling baby farming cases of the nineteenth century being revealed.

A graphic depiction of the victims and those responsible. (*Illustrated Police News*)

In the front kitchen, six babies, all seemingly just a few weeks old, were huddled together on a sofa under filthy shawls. All were severely neglected and two in particular looked close to death. Five more children were in other parts of the house, most being a few weeks old, although one or two were older and all looked as though they had been starved of food.

Surgeon, Edward Pope provided emergency treatment and was shocked to find one baby being fed from a bottle containing a mixture of corn flour and water, which was unsuitable. Another child's bottle contained just sour milk. He believed that several would die in the near future. Another baby had clearly been subdued by drugs and a bottle of the opium based Parageric Elixir and other drugs were found. A number of letters which tended to confirm that the women used false names and chose to collect the children away from their house were also discovered and one from a mother read;

> In reply to yours, I shall be happy to meet you at the Waterloo Railway Station on Friday afternoon at six o'clock in the first class ladies waiting room. Should this not suit you, will you favour me with a line. Yours truly A. J.
> P. S. Please to have my letter in your hand

When questioned, Waters said she had been accepting children for adoption for four years and had placed about forty. However, her sister blurted out 'Oh it is more than that', suggesting that a large number of babies had passed through their hands. The sisters claimed not to know their current whereabouts or to have details of the natural

or adoptive parents. A little later, Waters told the police 'What my sister has done was under my direction. I am the sinner and I must suffer'.

Six years earlier, Waters was living in comfortable circumstances with her husband in Newfoundland, but he died while he and his wife were visiting Scotland. She had a little money with which she bought several sewing machines and started a business in her rented home. Unfortunately the business failed and she was forced to take in lodgers. One of these asked her to look after her child while she worked and the idea of child minding on a more professional basis took hold. Initially she provided a good standard of care but soon afterwards greed led to her to decide to become a baby farmer of the worst type.

The sisters were brought before Lambeth Police Court where Waters was charged alone with failing to provide care for John Cowen and jointly charged with her sister for neglecting five other children, whose identities were not known. John was receiving hospital treatment and ten of those also discovered in the house were in the court's waiting room being cared for by the wives of local police officers. After the hearing, they were taken to the Lambeth Workhouse.

The trial of the two women opened in mid-August and they faced five murder charges. Four of the children found by Sergeant Relf had died, including John Cowen. The sisters were accused of failing to feed them, not providing medical care and drugging them repeatedly with laudanum.

Several unidentified dead babies had been discovered on Myatt's Field, which was situated close to Frederick Terrace in the months before the existence of the baby farm was known. The sisters were suspected of being responsible for those deaths but only one of these could be linked to Waters and Ellis. The decomposed state of the child's

The execution of Margaret Waters. (*Illustrated Police News*)

remains meant that its identity was not known, but items in the parcel were shown to have belonged to Waters and this was the fifth murder they were accused of.

Ellis was convicted only of obtaining money be false pretences by claiming the children placed in her care would be adopted and was sentenced to eighteen months imprisonment with hard labour. Waters was found guilty of only one murder, that of John Cowen and there was no surprise when the poorly supported petition for a reprieve failed.

1874

John Walter Coppen was executed on 13 October for the murder of his wife, Emma Coppen at Camberwell on 27 August.

Thirty-one year old Coppen and his wife who was one year his junior, had been married for eight years. For seven years they had run a public house in Reading but in January 1874 they bought a coffee shop at 36 Church Street, Camberwell. They were a hard working couple who had no children and who lived comfortably. However, he had a major problem with alcohol and for the two days before the murder he had been drinking heavily. This had led to many arguments and on the night of 26 August, Emma had refused to share his bed. The following morning, he was in the kitchen cutting meat as he was preparing beef steak puddings for sale later in the day. Also in the kitchen were his assistant Charlotte Berry and his sister Emily Coppen. The knife he was using broke and he went to the shop of butcher Edward Gold, which was opposite his own premises, to borrow a knife, which the butcher sharpened for him.

It was a little before ten o'clock when Emma came into the kitchen and offered to help, but her husband told her she was not needed. She told him she would go out instead, went upstairs and came down wearing her shawl and bonnet. He insisted she should not leave the shop and walked towards her, the knife still in his hand. She stumbled and cried out 'I am stabbed, I am dying'. Charlotte and Emily rushed to help her and could see the knife protruding from under her left breast. Dr Pinder was called to the shop but there was little he could do and Emma died thirty minutes later.

Sergeant Pearman had arrived and allowed Coppen to remain with his wife until she died, before arresting him. The officer heard her say repeatedly 'I am sorry for him, but I aggravated him'. He also heard her say to her husband 'I'm sorry it's you, I hope you are not punished'. At his trial, the jury recommended mercy, but despite this and the deathbed statements of his victim, there was to be no reprieve.

1876

On 19 December Silas Barlow was hanged for the murder of Ellen Sloper on 11 September at Vauxhall.

On 21 August 1876, twenty-four year old Ellen Sloper agreed to pay the weekly rent of 5s to lodge with Jessie Wilson at 18 Leopold Street, Vauxhall. Ellen had her six

months old baby with her and told her landlady the she was fortunate that the child's father, Silas Barlow, was supporting her and was paying the rent on her behalf. He was a widower in his early thirties, whose wife had died the previous year and who had a good job as a platelayer on the London, Brighton & South Coast Railway. The couple did not live together as he shared lodgings nearby with his cousin David Barlow, but he visited Ellen and the child regularly and struck the landlady as a doting father. Mrs Wilson had no objection to this arrangement as she found Ellen to be a respectable and pleasant young woman who cared very much for her child, who like its mother was in good health.

On 3 September, Barlow visited Ellen and spent an hour with her. After he left, the young mother called on her landlady complaining of nausea and feeling unwell. Mrs Wilson noticed her lips were almost white and she had difficulty in standing. Ellen said that she had begun to feel unwell after Barlow had given her a glass of sarsaparilla he had brought with him. However, she appeared to have recovered the following day and nothing more was said about the incident.

Seven days later, Barlow visited Ellen and the child again and Mrs Wilson later recalled that she was in excellent health. Nevertheless, an hour after his arrival, Barlow knocked on the landlady's door to say Ellen was very poorly having suffered two fits. She rushed upstairs to find Ellen having convulsions, her hands and feet clenched and her back forming an arch. James Miller, a Vauxhall doctor, concluded she was experiencing an epileptic fit. Crucially, neither Ellen nor Mrs Wilson mentioned the arched back, which may have alerted the doctor to the possibility of strychnine poisoning. Nor was the doctor aware that Barlow had once more given her a glass of sarsaparilla. Ellen died a few hours later at two o'clock in the morning, in great pain.

On the following day, Barlow took the baby, telling Mrs Wilson it would be cared for by a relative. The next time she saw the child was four days later when she identified its body, which had been retrieved from a Battersea reservoir.

Suspicion immediately fell on Barlow whose rooms were searched, revealing a bottle of vermin killer and several bottles which contained other liquids, some of which had labels with sarsaparilla written on them. These, together with the contents of Ellen's stomach were sent for examination by Dr Alfred Bernays, Professor of Chemistry at St Thomas's Hospital, who tested for strychnine. None was found in her stomach but traces were found in the bottles. The crown claimed that Ellen had been given strychnine in the sarsaparilla drinks Barlow had given her and he had later drowned his child. The motive was to rid himself of the burden of supporting them financially.

His defence argued that the evidence of strychnine poisoning was inconclusive, highlighting the initial diagnosis of epilepsy, the absence of the poison from her stomach and the fact that only small traces were found in some of the bottles. However, the jury agreed with the crown's case and after being convicted of Ellen's murder the charge of murdering the baby was not proceeded with.

1877

On 2 January Isaac Marks was executed for the murder of Frederick Barnard on Tuesday 24 October 1876 at Newington.

In 1874, thirty year old Russian émigré Izhack Parkraiak who had anglicised his name to Isaac Marks, met a Miss Barnard in Ramsgate and later she accepted his proposal of marriage. He was an antiques dealer and some months later his business premises were destroyed by fire, following which he was paid £300 by his insurance company. His fiancée's brother, Frederick Barnard, a thirty-seven year old umbrella maker of Penton Place, Newington, had helped him with the claim in return for which he was hoping to borrow some of the money. However, after receiving the pay out, Marks refused to make such a loan, which led to problems developing in the relationship of the two men.

Later, the engagement was broken off and this seems to have been particularly bitter. First, Marks sued his fiancée's father for the return of an oil painting he claimed was his property. This was followed by Marks being sued for breach of promise which resulted in an order for him to pay £50 compensation to his former fiancée. Frederick gave damaging testimony against Marks in both court cases which led to a worsening in their already poor relationship.

This was compounded further when Marks learnt from a mutual acquaintance that following his refusal to make him a loan, Frederick had approached the insurance company saying that Marks had set the fire deliberately to make the claim. The insurance company refused to take the matter further, but Marks was enraged when he heard what Frederick had done and he was determined to have his revenge.

At six forty five on the evening of 24 October 1876, the sound of children at play in Penton Place was shattered by the sounds of three gun shots fired in rapid succession. One of the youngsters, Ellen Parker turned to see a man lying on the ground and another running away. The gun, smoke still coming from the barrel, had been dropped at the scene and Ellen pointed it out to the police when they arrived a few minutes later.

On his arrival, Sergeant Underwood summoned Dr Badcock, who wiped the blood from the man's face. As he did so, the sergeant recognised the wounded man as Frederick Barnard. He was unconscious but still alive and the doctor attempted to give him a little brandy but he could not swallow and died a few moments later. The body was taken to the mortuary, where Dr Badcock found three gunshot wounds. One had entered on the left side of his chest, another had been fired into the right side of the neck, and the fatal wound was over the left eye. There was an injury to his head but this had been caused when he fell to the ground after being shot.

Meanwhile, Marks had walked into the local police station and confessed to Inspector Whelan. Later that evening, Ellen Parker identified him as the man she had seen running away after the shots had been fired.

This had clearly been a premeditated crime. Two weeks before the shooting, Marks had visited his friends John and Sophia Hyams and Sophia had asked him if he had settled his differences with Frederick. Marks had replied 'I don't think I shall see you

again. It is no secret, everyone will know it in time'. This caused Sophia a great deal of concern that this sense of resentment should fester for so long. Marks had asked her to tell Frederick that he should stop making life difficult for him or he would suffer. On hearing this Frederick had smiled and said he was not afraid of Marks. The police also learnt that on 20 October, Marks had purchased a six chamber revolver and fifty cartridges from gun maker Gustavus Masu. The bullets taken from the body were similar to those purchased by Marks.

Frederick was a widely respected man and was the father of nine children, whose ages ranged from thirteen years to a few months. A committee had been formed under the auspices of the Walworth Synagogue to raise funds for his family. This was of little concern to Marks who went to the gallows apparently content that he had had his revenge.

*

On 14 August Caleb Smith was executed for the murder of Eliza Osborne at Croydon on Saturday 14 April 1877.

Smith, a bricklayer, cohabited with his victim at 2 Collier's Cottages, South Croydon, and on the night of 14 April they were heard arguing. Eventually all went quiet but concerned neighbours gained entry to the cottage to find Eliza dead with blood pouring from a throat wound. Smith was lying next to her on the floor having suffered a similar wound. He was taken to hospital where he recovered following treatment.

Afterwards, Smith said that he believed Eliza was about to leave him having started a relationship with another man. As they argued he claimed that she had struck him and in response he had picked up a razor, seized hold of her and cut her throat, after which he attempted to kill himself. When he appeared before Mr Justice Grove to stand trial, his barrister argued that his client had been provoked by Eliza when she hit him and he should therefore be convicted of manslaughter and not murder.

In his summing up the judge reminded the jury that in considering the issue of provocation, they should be satisfied that the response was proportionate to the nature of the behaviour of the victim. If the jury concluded that he had killed her due to his feeling of jealousy having learnt of the new relationship and her threat to leave him, he should be convicted of murder. The jury, following a brief retirement, decided that he was guilty of the more serious crime and should hang.

1878

On 8 October Thomas Smithers was executed for the murder of Amy Judge at Battersea on 21 July 1878.

Thirty-one year old Amy Judge had been married to her husband for several years but he was a feckless individual who had served prison sentences for selling pornographic prints. During one of those periods in custody, Amy met and subsequently lived with a man by the name of Richard Hunt. However, he decided to emigrate to New Zealand

and she later met Thomas Smithers, also thirty-one years of age, with whom she began to live in Battersea. Smithers was a hardworking man of previous good character, who had worked in a Holborn hotel for many years.

All went well until 20 July 1878, when Richard turned up and asked Amy to accompany him to Bethnal Green to visit his sister. Smithers tried to prevent them from going but reluctantly agreed on condition he went with them. However, he returned home alone, having lost his temper and threatening to harm Amy if she should leave him, which he was convinced Richard was attempting to encourage her to do. She assured him that she would return later that night, but she did not and it was not until the following morning that she and Richard arrived back, telling Smithers that they had missed the last omnibus. Amy made Richard some breakfast which he ate before leaving.

An irate Smithers could not be calmed down and during the afternoon neighbours heard the couple arguing. When they heard Amy screaming, the front door was forced open from which Smithers emerged running. Amy was bleeding from several wounds to her body and soon died. She had been stabbed and the knife Smithers had used was found in the room close to the body. Dr Coombs later found that the main arteries of both arms had been severed and she had bled to death as a result of those and the other wounds she had suffered.

At his trial it was claimed that Smithers had suffered from epilepsy for a number of years, was delusional and was insane as his grandfather and other relatives had been. However, Mr Gibson, the surgeon at Newgate Gaol testified that he had observed the

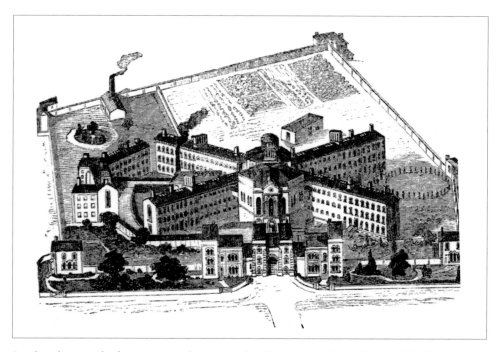

Smithers became the first person to be executed at Wandsworth Gaol. (*Author's Collection*)

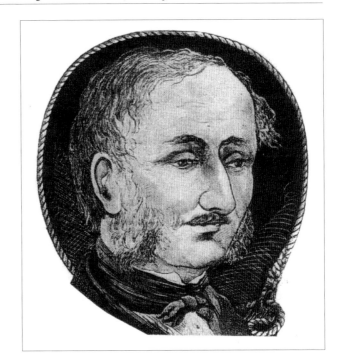

William Marwood was the
only executioner to perform
hangings at Horsemonger
Lane and Wandsworth Gaols.
(*Author's Collection*)

prisoner since his remand in custody and had seen no indications of insanity. The jury decided that he was guilty of wilful murder and after the judge told him he would hang Smithers collapsed and had to be carried from the dock.

1879

On 29 July, Catherine Webster was executed for the murder of Julia Thomas at Richmond on 2 March 1879.

On the morning of 5 March 1879, Henry Wrigley noticed a box, around which a cord had been tied, bobbing up and down in the Thames, close to Barnes Railway Bridge. Curious, he pulled it from the water and opened it. He was sickened when he saw the contents, for inside were what he could identify as burnt human body parts. A few days later, on the tenth, George Court was working on an allotment at Copthall. As he filled his wheelbarrow from a communal dung heap, he was appalled when he uncovered a human ankle and foot.

The remains were examined by Thomas Bond, surgeon at the Westminster Hospital and lecturer in Forensic Science. He concluded that they were from the same middle aged woman and included parts of both arms; the upper part of the chest, to which several ribs, the heart and a portion of the right lung were attached; the right lower leg, which had been cut away at the knee and from the foot, at the ankle; and there was also a portion of the pelvis with the uterus still attached. The surgeon described the dismemberment as having been performed by an unskilled hand and believed that

Catherine Webster.
(*Illustrated Police News*)

the body parts had been boiled, possibly to facilitate the task. This would later give rise to a rumour circulating that the murderer had sold the body fat as dripping. It was impossible to determine the cause of death, but she had died within the previous fortnight.

There was no means of identifying the remains now lying in the mortuary, but the police were aware of concerns that had been expressed about the wellbeing and whereabouts of fifty-six year old Julia Martha Thomas, who lived at 1 Vine Cottages, Richmond with her live-in servant and who was last seen on Sunday 2 March.

On that day, she had attended the morning and evening services of the local Presbyterian Church and among those who saw her was her friend Emma Roberts, who called at her home the next day. However, there was no reply when she knocked on the door. Coal merchant, William Dean, met Julia on that Sunday as she made her way to church and arranged to call on her the next day when she told him she would settle her account. However, he too gained no reply when he called at her house the following lunch time.

The missing woman lived next door to her landlady and her mother, Elizabeth and Jane Ives. On the Sunday night, after Julia had returned from church, Jane had heard a sound similar to that of a heavy object falling to the floor coming from next door. The next morning, Elizabeth was in her garden and was almost overwhelmed by a sickening smell, which seemed to be coming from next door.

Julia was not seen again by any of her friends, neighbours or by a number of tradesmen who attempted to contact her. However, her live-in servant, Catherine Webster who was seen regularly over the following days, advised those who enquired

The killer disposing of body parts in the River Thames. (*Illustrated Police News*)

PUSHING THE BOX OVER THE BRIDGE

that Mrs Thomas was away visiting friends. Webster was seen in the company of two men on several occasions, apparently attempting to sell Julia's furniture.

The police were keen to interview Webster, having discovered that she was a petty criminal who had served several prison sentences for offences of dishonesty. However, she had disappeared together with her young son, who had been living with his mother's friend, Sarah Crease. The two men who had been seen in the servant's company, were traced having been identified as Henry Porter and John Church and were interviewed.

Henry Porter said that he and his family had lived next door to Webster several years earlier, when she was exceptionally kind to his dying daughter, but he had not seen her for six years. That was until she visited him unexpectedly at his Hammersmith home on 4 March. She informed him that a wealthy aunt had died and left her a house in Richmond, which she wanted him to help her sell together with the contents and other items. Henry agreed to help and introduced her to his friend, John Church, landlord of the nearby Rising Sun, who also offered to assist. Henry also revealed that his son, Robert, had helped her carry a heavy case to Richmond Bridge, which she threw into the river.

Articles discovered with the body parts were linked to the missing woman and although it had not been possible to establish the cause of death, the investigators were satisfied that the remains were those of Julia and that she had been murdered. They believed that the noise heard by Jane Ives after the missing woman had returned home

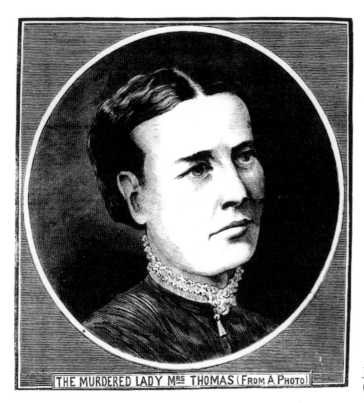

THE MURDERED LADY M^{RS} THOMAS (FROM A PHOTO)

Julia Thomas.
(*Illustrated Police News*)

from church was the murder taking place; the sickly smell noticed by Elizabeth Ives the following day was caused when Webster was boiling the body parts; and the police were convinced that Robert Porter had unwittingly helped the murderer carry some of the body parts to a spot at which they were thrown into the river. Financial gain was the motive and Webster was their only suspect.

It was known that Webster had family in Enniscorthy and the Irish police were contacted. They had little difficulty in locating and arresting her as she had travelled there with her son. Inspector John Dowdell of Scotland Yard took the ferry across the Irish Sea to charge her with murder and bring her back to England to stand trial.

Webster denied having committed the murder, placing the blame on John Church and Henry Porter. Despite Church's claim to have met her for the first time in early March, she insisted they had known each other for seven years. They had met again in late 1878 and resumed their relationship. He visited her at Mrs Thomas's home and a few days later had suggested poisoning her, selling her property and travelling to America together as he was tired of his wife. She claimed that she had refused to be part of any such plan.

He called at the house again on 3 March as she was leaving to visit her son, meaning he was alone in the house with her employer. When she returned later that night, he answered the door and Mrs Thomas was writhing in agony on the floor, apparently having been poisoned. Henry Porter was also said to have been in the house and

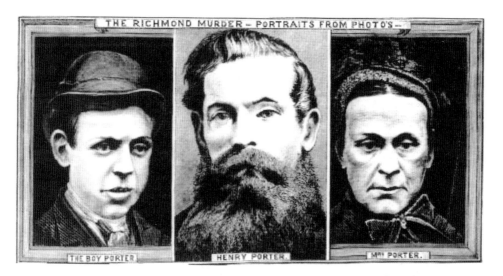

The Porter family became Webster's unwitting accomplices. (*Illustrated Police News*)

Webster was threatened with death if she revealed what she had witnessed, hence her decision to flee with her son.

Credence was initially given to her story which resulted in the arrest of John Church on 1 April. However, he was subsequently released without charge after he and Henry Porter were able to produce alibis. Nevertheless, she persisted with this version of events, but both men testified against her at her trial. She was not believed and after being found guilty she was sentenced to death.

It was only after being informed that there was no hope of a reprieve that she admitted full responsibility and cleared both men of any role in the crime. She left a written confession in which she described an argument taking place on Sunday 2 March between her and Mrs Thomas. On her employer's return from church that evening she struck her with such force that she died. When she realised what she had done she decided to try and make as much money as he could by selling her property.

There was a loud cheer of approval from the crowd of three hundred gathered outside the prison gates, when the black flag was raised, indicating that the execution had been carried out.

1882

On 28 April, George Lamson was hanged for the murder of Percy Malcolm John at Wimbledon on 3 December 1881.

Eighteen year old Percy had been orphaned in 1869 following the death of his mother, the widow of a wealthy Manchester merchant. He was paralysed from the waist down and unable to walk. He was one of five children, but his two brothers had died young and he had two surviving older sisters. Kate was married to Dr George

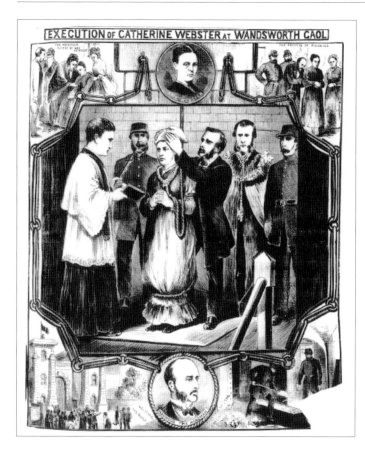

The execution of
Catherine Webster.
(*Illustrated Police News*)

Henry Lamson and Margaret was the wife of civil servant William Chapman. Percy was well off, having inherited capital amounting to £3,000, which earned him an annual income of £109.

In 1878, Percy started as a boarder at Wimbledon's Blenheim House School, where he was hugely popular with his fellow pupils. The headmaster, John Richardson, arranged for a wheelchair to be placed on the second floor, where Percy's bedroom was situated and another in the basement, where he attended lessons during the day. His three room mates were happy to share the task of carrying him up and down the stairs when necessary.

He was also visited regularly by his family and on 2 December 1881, he received the following note from his brother-in-law;

> My Dear Percy, I had intended running down to Wimbledon to see you today, but I have been delayed by various matters until it is now 6 o'clock and by the time I should reach Blenheim House you would probably be preparing for bed. I leave for Paris and Florence tomorrow and wish to see you before going. So I propose to run down to your place as early as I can for a few minutes, even if I can accomplish no more. Believe me dear boy, your loving brother, G. H. Lamson.

True to his word, Lamson arrived at the school shortly before seven o'clock the next evening and spent half an hour with Percy and the headmaster. Neither of them had seen the doctor for several months and both were surprised to see how sickly and emaciated he appeared. He had bought a Dundee Cake, wafers and sweets which the three ate with a glass of sherry. He later produced a number of small empty capsules, which he said he had come across in America. He explained that they were easy to swallow and quickly digested, making them ideal for someone such as Percy who had to take unpleasant tasting medicines on a regular basis. He suggested Percy take one and apparently added a little sugar, before sealing it. Percy agreed it was indeed very easy to swallow and hid the taste of what was being taken.

Within minutes of Lamson leaving, Percy began to feel unwell and complained to the headmaster of feeling just as he had done some months earlier after his brother in law had given him a quinine tablet when on a family holiday in Shanklin on the Isle of Wight. The youngster's condition deteriorated rapidly and he was carried to his room accompanied by the matron, Mary Ann Bowles. He was clearly in pain, vomited a great deal and suffered violent convulsions which meant he had to be held down to prevent him from harming himself. There was no improvement and he died at eleven thirty that night.

School staff suspected Percy had been the victim of foul play and the police were contacted the following day. A post-mortem revealed no immediately obvious cause of death, but the sugar, wafers, sherry, sweets and Dundee Cake together with samples of his vomit, stomach contents and internal organs were sent to Thomas Bond at Westminster Hospital for examination. The tests he conducted led the doctor to conclude that an irritant vegetable poison had been administered to Percy. He knew of only one previous case in which it had been used, but he was of the opinion that aconite was the poison responsible for the youth's death. Traces of the poison were found in Lamson's property and he was thought to have added it secretly to the sugar in the capsule, which he had handed to Percy during his visit to the school.

The police learnt that Lamson had bought two grams of aconite from chemists Allen & Hanbury on Lombard Street at a cost of 2s 6d, which they believed he had used to commit the crime. Enquiries on the Isle of Wight confirmed that he had obtained a quantity of the poison from chemist David Littlefield of Ventnor. He was thought to have used this to make an initial murder attempt, which is the incident Percy recalled on the night he died.

Convinced they knew the means by which the murder was committed, the police soon established a motive for the crime. Three years earlier, Lamson had set himself up in practice in Bournemouth, claiming to have qualified at London University as a Doctor of Medicine and to have been awarded a science degree by Cambridge University. However, the Bournemouth authorities discovered these claims to be untrue. He was in possession of a licence issued in 1887 enabling him to practice in Edinburgh only. His lies having been uncovered, he was refused permission to practice in the town and subsequently found it impossible to establish himself in another practice elsewhere.

Unable to earn a living and now addicted to morphine, which explained his emaciated appearance, he fell into debt. He owed several hundred pounds to friends on the south coast and his furniture and other property had been seized for non-payment of rent.

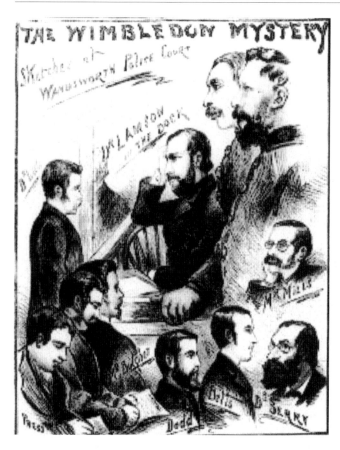

Lamson makes an early appearance at Wandsworth Police Court. (*Illustrated Police News*)

He had opened an account with the Wilts and Dorset Bank in November 1880 but within three months the bank wrote to him confirming they would honour no more of his cheques, although he did not return the cheque book.

In April 1881 he sailed to America where he had relatives, possibly hoping to make a new start, but returned to England in October. For the next few weeks he borrowed heavily to survive and cashed cheques using his old Wilts and Dorset Bank cheque book, which he knew would not be honoured. It also emerged that he had been staying at Nelson's Hotel on Great Portland Street and left a few days before Percy's death, owing £7 17s 7d. On 24 November, he pawned his surgical instruments and a gold watch, for which he received £5. Percy's death would result in his capital being divided equally between his two sisters and Lamson it was believed, committed the murder so that he would have access to half of his estate.

Inspector James Butcher of Scotland Yard was put in charge of the case and on 8 December sent Sergeant Moser to Paris, where it was thought Lamson was staying. However later that day, the suspect, accompanied by his wife, arrived at Scotland Yard. He claimed to have read about Percy's death and that he was a suspect, in the Paris newspapers and had travelled to London to clear matters up. However, he was arrested and charged with the youngster's murder, which he denied all knowledge of.

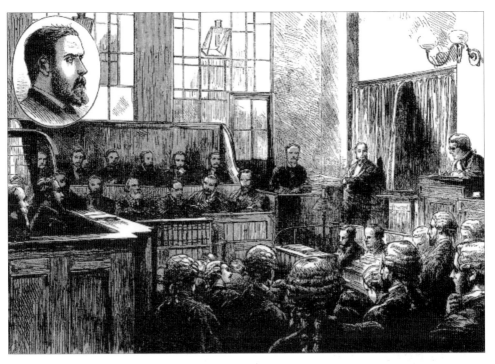

Lamson's trial was one of the most sensational of the Victorian age. (*Author's Collection*)

The evidence against him was sufficient for the jury to convict him after which he was sentenced to death. An attempt was made to gain a reprieve on the basis that he was insane. His American relatives sent depositions confirming that his aunt, great uncle and grandmother had been confined in the Bloomingdale Lunatic Asylum in New York, where they had died. When visiting America, Lamson too had behaved strangely and it was thought that his mental problems had been exacerbated by his morphine addiction. This, they believed meant he had not realised what he was doing when he administered the poison to Percy. The petition, however, was unsuccessful.

*

On 12 December Charles Taylor was executed for the murder of his wife Caroline Elizabeth Taylor at Camberwell on Friday 18 August.

The Taylors rented a parlour, bedroom and shop at 2 Tustin Street, Old Kent Road, Camberwell, from fishmonger Henry Dennington, who lived on the floor above with his wife. Thirty-nine year old Taylor was a carpenter and his wife who was two years younger was a wardrobe dealer.

At two o'clock on the afternoon of 18 August, the Taylors' fifteen year old daughter Caroline left her parents at home to visit a friend nearby. Her parents had been arguing that morning but were apparently on good terms when she left them. She had been with her friend for about an hour when she decided to return home. On opening the

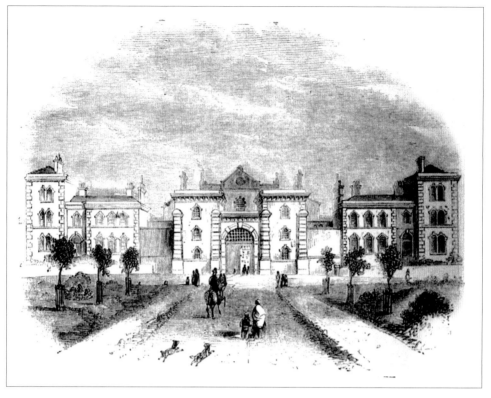

Following the abolition of public executions, crowds would assemble outside the gates of Wandsworth Gaol on the morning an execution was to take place. (*Author's Collection*)

door, she saw her mother lying on the floor in a pool of blood and her father kneeling at her side and about to slash his throat.

Alerted by the distressed girl's screams and having seen the bloody scene in her parents' room, Mr Dennington went in search of a doctor and the police while his wife comforted the hysterical youngster. It was discovered that both had suffered extensive throat wounds and although Taylor was still breathing, his wife was dead. He was barely conscious but was able to describe what had happened to Inspector Levett, who had arrived at the scene and asked him who was responsible, Taylor nodded towards a knife close to his wife's body and replied 'I did, with that. She was always nagging me'. He fell unconscious before being rushed to Guy's Hospital. He was not expected to live but excellent medical treatment meant that he survived and was thus able to face the noose.

1883

On 6 November Henry Powell was executed for the murder of John Dimery Bruton at Balham on Thursday 27 September.

In May 1883, twenty-three year old bricklayer Powell was employed by stonemason John Bruton, who was building two villas on Ormley Road, Balham. On 8 September the two men argued after Powell had demanded £3 10s for work he had completed, but for which he had been paid only £3 by his employer, who had told him that if he finished the work satisfactorily he would pay him the balance the following week. Powell, however, did not turn up for work all week and John had to employ another bricklayer. John claimed that Powell owed him money for materials purchased but not used and the two men arranged to meet at Ormley Road on the morning of the twenty seventh to settle their dispute.

Twenty-five year old John Dimery Bruton was the stonemason's son, who was overseeing the building of the villas on behalf of his father and arrived at the site before his father that morning. At nine thirty, Powell approached the younger Bruton and without warning began to strike him about the head with a heavy stonemason's chisel. Two workmen rushed over to try and assist John but they were too late. He lay motionless on the ground, bleeding heavily from a number of head wounds. Powell began to walk away from the scene and said to the workmen, 'I have done it now, I have settled him'. Some minutes later he approached Constable Purt, who was standing outside the Balham Court Tavern, to whom he confessed and with whom he returned to the murder scene. Surgeon Benjamin Godfrey arrived but could do nothing other than certify the victim as being dead. He had suffered seven serious wounds to the head, from which his brains were protruding.

The Balham Murder.
(*Illustrated Police News*)

At his trial the defence argued that their client should be convicted of manslaughter as he had been provoked by the deceased, who had struck him with an umbrella. However, it was shown that he had threatened violent revenge earlier in the week and the jury took thirty minutes to convict him of wilful murder. As he sentenced him to death, Mr Justice Denman described his sense of incredulity that such a premeditated and brutal crime should have occurred due to a dispute with the victim's father for the paltry sum of 10s.

1885

On 13 January 1885 Horace Robert Jay was executed for the murder of Florence Ellen Kemp at Clapham on 29 September 1884.

Jay, a twenty-three year old barman working at the Clarence in Clapham and eighteen year old Florence Kemp, who worked for the cigar manufacturer Faulkner's of Battersea, met during the Christmas holiday period in 1883. They soon developed deep feelings of affection for each other and began courting. At Whitsuntide they visited Farringdon where they spent several happy days. On their return to London they decided to live together as Mr and Mrs Harry Thorpe, his mother's maiden name. They found lodgings on Stanmore Street, Battersea and made plans to marry.

In July, Florence returned to live with her parents and this was with her fiancé's agreement. He found new lodgings with Isabella Weimar at 35 Larkhall Lane, Clapham. Their plans to marry remained unaltered and the couple again visited Farringdon, travelling on 22 September and returned four days later. Florence went back to her parents' home and Jay to his lodgings.

That night, however, Jay visited Florence but was told by her parents that she had gone to the nearby Music Hall with her brother Arthur, her cousin and another young man named Thomas. Jay waited for them to return, when in a jealous rage he struck Florence with a stick. In response to this attack on his sister, Arthur struck him on the side of the head and badly injured his ear. He berated him for hitting his sister and in response Jay said 'I am the person who has the right to govern her'.

Any ill-feeling did not seem to last long for two days later, at five o'clock on Monday 29 September, Florence accompanied Jay to his lodgings, where they had decided to live after their forthcoming marriage and she was keen to view the apartment. Both seemed to be in good spirits as they sat drinking tea with Mrs Weimar in her kitchen discussing their future plans. After a little time had passed, Jay said he was going to lie down in his room as he felt unwell. Florence finished her cup of tea and said farewell to Mrs Weimar before going to Jay's room for her hat and coat.

Five minutes later, Mrs Weimar heard a series of loud shrieks coming from Jay's room. She rushed upstairs, flung open his door and saw the young couple struggling on the floor. Florence screamed 'Stop him' as the horrified landlady watched Jay, who was holding an open razor, draw it across Florence's throat. Both staggered to their feet, and showing great composure, Isabella took the razor from his hand, and shouted to another lodger, Mrs Rundle, to bring help.

Florence collapsed to the floor and as she did so, Jay took another razor from a pocket, which he opened and with which he slashed his own throat in a suicide attempt. Dr Joseph Sutcliffe and Constable James Holdaway were soon at the scene and arrangements were made to take the young couple to St Thomas's Hospital, where both were treated by surgeon, Henry Robinson. This was not before Florence had confirmed to the police officer that Jay was responsible for her injuries. Jay had made a determined effort to kill himself but survived. Florence had suffered extensive damage to her major veins and arteries and she died at eight o'clock the next morning.

At his trial, the crown suggested to the jury that despite apparently having calmed down following their violent argument on the Saturday night, Jay had remained annoyed that she had visited the Music Hall with another young man. He was unable to accept that this was wholly innocent and he seemed convinced that she was going to end their relationship. It was discovered that he had attempted to commit suicide after leaving her on Saturday night, by swallowing a match and when that had failed, he had decided that if he could not have her, nobody else would. The defence argued that although there was no history of insanity in his family, the blow to the side of his head on the Saturday night, had caused him to suffer a series of fits over the following hours which meant he was not responsible for his actions. This proposition was rejected by the jury which returned with a verdict not of manslaughter but of wilful murder.

The murder of Florence Kemp. (*Illustrated Police News*)

As he awaited execution, his victim's mother, Charlotte Kemp agreed to visit him in Wandsworth Gaol, where in an emotional meeting, this courageous, kind-hearted and decent woman forgave him. Furthermore, she signed a petition seeking a reprieve for him. Nevertheless, the execution went ahead and the fear that the partially healed throat wound would burst open as he fell through the drop proved to be unfounded.

1889

On 6 March Ebenezer Samuel Wheatcroft Jenkins was hanged for the murder of Emily Joy at Farncombe on Monday 7 January 1889.

Jenkins, a twenty-one year old artist was estranged from his family and was living at the home of his nineteen year old fiancée, Emily Joy and her mother on Church Street, Farncombe. On Christmas Day 1888, Jenkins drew up a document in which he undertook to marry Emily on any day she wished and he also included details of his means. He wrote that he had £500 in the bank and would inherit a similar amount on his thirtieth birthday. Within a few days, the couple decided to marry in early March and to buy a house in Bognor.

Two weeks later, on the evening of Monday 7 January, Jenkins asked Emily to accompany him to his studio which was situated at the bottom of a neighbour's garden. He told her that he had arranged to meet a Mrs Elliott who was to repay £14 she had borrowed from him. At eight o'clock the couple left the house but had not returned by midnight. Mrs Joy knocked on the door of the studio, which was locked and in darkness. Receiving no response, she presumed the couple had decided to visit friends with whom they were spending the night.

Unfortunately, this would prove to be wrong, for Jenkins had raped and murdered Emily after which he fled, leaving her body in the studio. At a few minutes after eight, he had visited the Sun Inn, where he drank six pennyworth of brandy, which he paid for with a jubilee half-crown. Later, this was found to have been removed from Emily's brooch after he had killed her, but robbery was not the motive for the crime. As he drank his brandy he spoke with Arthur Singer, telling him that on the following day he was leaving for Egypt.

After leaving the Sun Inn he took the Haslemere road on which at nine o'clock, he met a boy named Harry Pennycot, who later told police that he became worried at his companion's strange behaviour. He asked the young lad if he knew of any girls who were available as he had plenty of money to spend. He also told Harry that he was going to commit suicide and before parting, he insisted that the boy take his cuff-links, which he took off and handed to him. Later that night Jenkins reached Haslemere, where he spent the night in the Seven Thorns public house.

The next day, Jenkins walked into the Punch Bowl Inn at Hindhead and paid one penny for a glass of ale. The landlord, Augustus Sellers noticed that he seemed to be in low spirits and began to cry. Jenkins told Augustus that he was upset due to a failed suicide pact. He said he and his fiancée had decided to drown themselves but his courage had failed him after she had thrown herself into the river. Jenkins said he

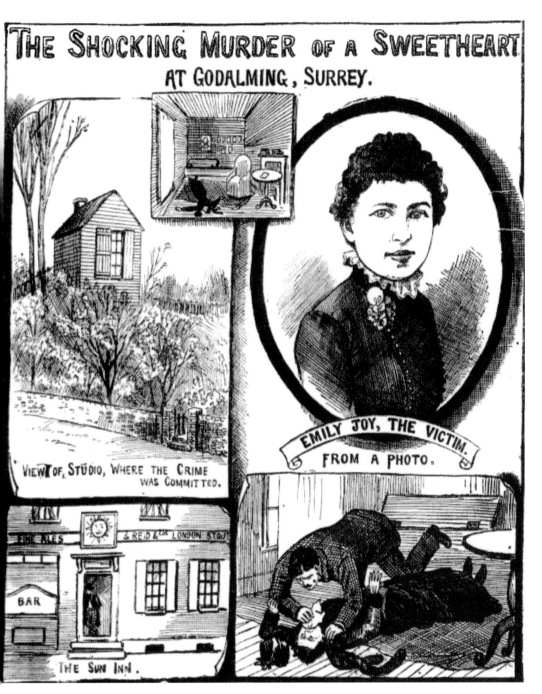

Scenes relating to the murder of Emily Joy. (*Illustrated Police News*)

wanted to make a statement to the police, but no officer was available in the town when the landlord sent for one.

Augustus decided to take the man to Guildford, where on arrival, Jenkins saw a friend and attempted to speak with him. However, Augustus insisted they go directly to the police office. It was at this point that Jenkins blurted out to Augustus that he had been lying to him and he had in fact strangled his fiancée. Later, at the inquest into Emily's death, Augustus was commended by the coroner's jury for his actions in detaining the murderer and ensuring he was taken into police custody.

Once he was in the Guildford Police Office he confessed to killing Emily and told officers where her body would be found. The brief confession was written down and signed by Jenkins;

> I wish to give myself up for murdering a young woman near Godalming last night. What I am going to say is true. I took the young lady into my studio in Mr Harrison's garden in Crown Pits last night. She is Emily Joy, with whom I have been keeping company. I told her we were to meet a woman there; but that was false. While she was standing looking at some papers I took her by the throat and the back of the head, threw her on the floor, and strangled her. Here is the blood from her mouth on my wristband and (pointing to his hand) this is where she bit me while I was doing it. This is the key of the studio door. If you go there you will find that what I say is true.

Emily's body was discovered as he said it would be, lying on her left side, her face horribly distorted and her neck badly bruised. Her boa had been used to strangle her and her handkerchief had been forced into her mouth. Before being killed the medical examination showed that she had been raped in a most savage manner.

Later on Tuesday, Emily's mother received the following letter posted by Jenkins in Mousehill the previous day;

> Darling Mother, you will be deeply grieved to hear that Emmy and me are gone forever. You will never see us again. We loved each other and swore we would never part. Dear mother, forgive me for all we have done. Let us be buried together, please do, in the same grave. So good-bye E. S. W. Jenkins.

This letter was posted before the crime was committed but his claim to have entered into a suicide pact with his victim was disbelieved and was seen as an attempt to lessen any punishment he would receive. In truth, he was a failed artist without an income, who had borrowed heavily and his claims to have a substantial amount of money in the bank and to be the recipient of another large amount when he reached thirty, were shown to have been lies. At his trial his defence claimed that his bizarre behaviour following the killing proved that he was insane at the time, should the suicide pact claim not be believed. The jury decided that he had feared, perhaps wrongly, that with the wedding drawing closer his lies would be discovered and Emily would refuse to marry him. Unable to accept this, he had decided if he could not marry her then nobody else would.

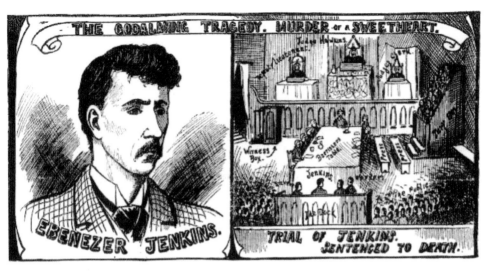

A portrait of the murderer and the moment he is sentenced to death. (*Illustrated Police News*)

1890

On 10 June, Daniel Gorrie was executed for murdering Thomas Furlonger at Brixton on 12 April.

It was mid-afternoon on Saturday 12 April and Nevill's bakery on Millwood Road, Brixton was almost deserted. Many of the work force had received their wages at noon after which they had changed out of their work clothes and left until Monday morning. At three thirty, John Morer, one of the yard boys, was sent to Furnace Room Number 1 to ensure all was well before he too would be allowed to go home.

On entering, he saw what he thought was somebody asleep on the floor at the far end of the room. As he drew closer, however, he realised it was the body of Thomas Furlonger, known to his friends as Nabob, a sixty-one year old packer. There was a great deal of blood and initially John thought he might have fallen and cracked his head open. However, a doctor arrived and confirmed he had received five serious injuries to his head and that he had died of a fractured skull.

The police discovered an iron bar, covered in blood which had been used to kill him. The linings of his trouser pockets had been pulled out as though someone had searched them. Indeed, robbery was quickly established as the motive for the murder as there was no sign of his wage of £1 3s 1d he had received a short time earlier. It was known to all staff that Thomas was always the last packer to leave at two o'clock as it was his job to wait until his colleagues had washed and dried themselves and take the towels for washing. This he had done and must have been about to leave the bakery when he was attacked.

Frank Harding, a packer, told police he saw Thomas as he was leaving the bakery at ten minutes to one and also that he had met another workmate, Daniel Stewart Gorrie, entering the building. Gorrie was a baker and had been working that morning but had left almost three hours earlier. In previous weeks, there had been a series of thefts at the

bakery and Frank became suspicious. He asked Gorrie why he had returned, to which Gorrie replied that he had come for his tobacco pouch, which he had left behind.

The police called on Gorrie the following day and their suspicions were further aroused when they saw scratches to the back of his hand, which he claimed had been caused by scraping it along a fence. They also noticed specks of blood on his clothing. When asked to give details of his movements after receiving his wages, he claimed to have gone to the Fox Under The Hill tavern on his own rather than to the Milkwood Arms with his fellow bakers which he usually did. He repeated his claim to have returned to search for his tobacco pouch, which had been the sole reason for being at the bakery at about the time the crime occurred.

He also insisted that on reaching Milkwood Road he had noticed two youths unknown to him, acting suspiciously outside the bakery entrance. However, the police believed these young men did not exist and he was attempting to deflect suspicion from himself. Further enquiries led the police to discover that he had borrowed heavily in the previous weeks and had repaid one debt of £1 on the Saturday night, just a few hours after the murder. This was after his wife had confirmed he had given her all of his wages, which totalled £1 13s 0d, on Saturday lunchtime.

This evidence was enough for the jury at his trial to believe the crown's case that this had been a premeditated and cold blooded killing as Gorrie knew that the bakery would have been almost deserted and that his victim would still be in possession of his wages.

*

On 29 July George Bowling was executed for the murder of Eliza Nightingale at Mitcham on Saturday 17 May.

Fifty-one year old Bowling and his fifty-six year old victim lived together at 1 Miles's Cottages, Mitcham. Eliza's sister, widow Sophia Collins, lived in rooms on the floor below the couple and on 16 May she heard them quarrelling. Eventually, all went quiet and on the afternoon of the following day, concerned that she had neither seen nor heard her sister, Sophia went upstairs to make sure she was well.

Regrettably, she found Eliza lying on her bed, still in her nightdress, clearly dead. She was covered in blood and had suffered serious head injuries. Dr Henry Love found eleven wounds to the right side of her head and she had been dead for several hours. There was no sign of a struggle and he concluded that she had been attacked as she slept. A hammer with blood stains and traces of her hair on it was on the bedside table and had obviously been used to murder her.

Bowling was arrested and confessed to the murder, saying he had been in a temper when he beat her after they had been arguing.

1891

On 21 July Franz Joseph Munch was executed following his conviction for the murder of James Hickey on Wednesday 22 April in Bermondsey.

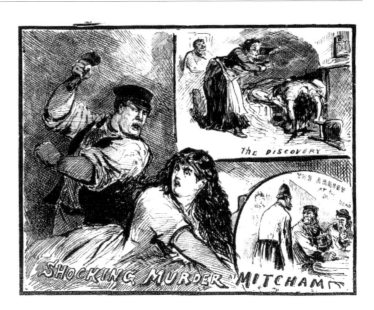

The brutal murder of Eliza Nightingale. (*Illustrated Police News*)

In August 1890, German born baker Franz Munch started work for widow, Bridget Konrath, who owned a bakery at 49 Lucey Road, Bermondsey. He made no attempt to hide his growing admiration for his employer and that he hoped to marry her at some stage in the future, although she seems not to have given him any encouragement.

On 22 March, her cousin, James Hickey, travelled from Ireland to stay with her at Lucey Road and Munch quickly came to view him as a threat to his plans and became increasingly jealous. The men argued regularly and on one occasion James referred to him as a 'German bastard'. Munch was heard to say to the man he viewed as his rival 'You want to be boss of this shop. You are not here for a good purpose'. He would not believe James when he denied having any interest in the business, but as her cousin he had every right to look after Bridget's interests.

A few days before the murder, James had been reading a newspaper article at the breakfast table about tensions between German and British settlers in southern Africa and made disparaging comments about Munch's countrymen. The bake house door had been open and Munch had clearly heard what was said. Later that day, Munch told Bridget that he would swing for her cousin. Unfortunately, this was not the empty threat Bridget had imagined it to be.

At a little after midnight on Wednesday 22 April, James returned to the shop with a friend Joel Diamond and as he opened the front door, Munch shot him in the chest without any warning. Two police officers were nearby and immediately rushed to the scene. Constable Craske arrested Munch who made no resistance and admitted to the shooting. Constable Hamilton took the wounded man to the Lord Palmerston public house where he was given a glass of brandy, but he died a few moments later.

At his trial the jury took very little time to convict Munch of wilful murder and although a petition was raised to secure a reprieve on the grounds of provocation, the execution went ahead as scheduled.

*

On 19 August Robert Bradshaw was executed for the murder of his wife Emma at Bermondsey on 4 July.

Bradshaw and his wife Emma, both of whom were in their fifties, had been married for several years and lived at 24 Smith's Buildings in Bermondsey. He was employed at Hay's & Butler's Wharf and when drunk was known to become violent and such was his reputation that to his workmates he was known as 'Mad Bradshaw'. At home his violence would be turned against Emma and he had been heard by friends and family members threatening that one day he would swing for her.

On a number of occasions the long-suffering Emma had been driven to take out a summons intending to take him to court, but she had always been persuaded to withdraw it at the last minute. On 29 June, she took out another summons and as the day of the court hearing drew closer in early July, it was becoming increasingly clear that she was determined that she would not be withdrawing it this time.

On 4 July, their married daughter Mrs Wild heard him tell her mother after she had confirmed she would not back down 'You shall never live to carry it out'. He refused to eat his dinner and went upstairs to the bedroom. He called down for a cup of tea and asked that Emma bring it to him. She did so and once more he pleaded with her not to take him to court, but again, she refused. Their daughter heard him scream 'If you won't withdraw it, I'll withdraw you'. She heard her mother respond by shouting 'If you touch me, I'll scream murder'.

There was a brief silence followed by her mother crying out 'Murder, murder'. The door was locked from the inside and had to be forced open by neighbours, who on gaining entry found Emma lying on the floor. She had been stabbed to death and there was a gaping wound at her throat. He simply said 'I've done it, I've had my revenge'.

There was little public sympathy for Bradshaw whose prediction that he would swing for Emma eventually came true.

1892

On 11 October John Banbury was hanged for the murder of Emma Oakley at Camberwell on 29 June 1892.

It was at two o'clock on the afternoon of Wednesday 29 June that Banbury approached the hansom cab of Henry Briggs close to Westminster Bridge. The two men knew each other as Banbury was the brother of the cabman's daughter-in-law. He had returned to London twelve months earlier from Australia, where he had lived for several years, since when he had not held a job but had lived by gambling on horse racing. The two men had met occasionally and would enjoy a drink together. Today would be no exception and they drove to the Southampton Restaurant on Chancery Lane where Banbury drank several glasses of gin. Later, Banbury asked to be taken to Camberwell Park and at the Grosvenor Arms the young man drank a few more

gins. Henry decided to change his horse at the nearby stables and agreed to return for Banbury, who was now very drunk, ten minutes later to take him to Victoria.

They met as arranged but Banbury had changed his mind and asked to be taken to Charing Cross, where, as he was stepping out of the cab, he invited Henry to have a last drink with him, adding 'I have shot a girl'. Henry found the very thought of such an occurrence so unlikely as to be highly amusing and agreed to have another drink in the Griffin. Banbury persisted with his claim, saying 'I loved her and swore nobody else would have her'.

As they walked towards the cab, Banbury pulled a revolver from his pocket, which a surprised Henry grabbed hold of immediately. He also demanded that Banbury hand over any spare cartridges and he gave eighteen to his friend. Henry still did not believe a shooting had taken place as the six chambers had bullets in them and it did not seem to him that the revolver had been fired recently. He intended keeping it temporarily and handing it back when Banbury was sober. Another fare hired the cab and the two men parted.

Sadly, the twenty-two year old Banbury had indeed shot and killed a young woman, Emma Oakley, also in her early twenties, in the few minutes that it took Henry to change his horse. Emma had lodged with Emma Foster at 81 Grosvenor Park, Camberwell for the previous fifteen months. Her lodger enjoyed a glass of beer but she had posed no problems for Mrs Foster. Banbury had been a regular visitor during the previous two months and the couple seemed to be very fond of each other.

The landlady was not surprised therefore to see him enter her room at a few minutes to four that afternoon. However, she was astonished to hear the sounds of five shots and to see Banbury running from the house. Mrs Foster rushed to the smoke filled room to find the young woman, who was wearing only an Ulster, lying on the floor with blood pouring from a number of wounds. Later, a post mortem performed by Joseph Carritt revealed she had bled to death from four bullet wounds to her head and face. She had also been shot in the hand as she had made a futile attempt to defend herself.

Two hours later, Banbury called at the home of his friend George Barkwall on Westminster Bridge Road. George owed him £10 but Banbury told him 'George, the money you owe me, I give you. I have shot my girl'. He continued by saying he had earlier seen her leaving a pub wearing only a dressing gown accompanied by two men. He had been overwhelmed by jealousy and a need to avenge his sense of betrayal. He complained that he had spent £40 on her during the previous fortnight and had been expecting to marry her in a few weeks' time. Banbury arrived back at his lodgings at 6 Brewer Street, Pimlico, to discover several police officers waiting to arrest him. It was on the following day that Henry Briggs handed the murder weapon and the cartridges to the police and Banbury was charged with murder.

At his trial, the defence attempted to prove that the killer was insane and called several witnesses who testified that two cousins, William and John Devenish, were mad and confined in a London asylum. Another told the court that an aunt had died in a lunatic asylum in Australia some years earlier. Furthermore, his grandfather had been insane and was locked in the cellar of the family home for many years and on one occasion had chased a visitor down the street threatening him with a saw. However,

Dr Philip Gilbert of Holloway gaol, who had observed the prisoner daily since his arrest, insisted he was sane.

The jury retired for two hours and returned with a guilty verdict but also with a strong recommendation for mercy due to his youth. Before sitting down, the foreman added that he felt he should mention that two members of the jury were deaf and had heard none of the evidence given during the trial. The trial judge, Mr Justice Collins, showing admirable restraint on hearing this, directed that they should be discharged and the evidence be given again before a new jury. This was done and a similar verdict reached.

1895

Joseph Canning was hanged on 18 June for murdering Jane Youell at Bermondsey on Friday 26 April.

Canning, a thirty-four year old nurse and former soldier, had lodged with the Youell family at 41 Delaford, Bermondsey for some time. He admired Jane, their twenty-one year old daughter and they appeared to be very fond of each other. It is not clear whether or not he misread the true nature of her feelings for him, but he clearly came to believe that she loved him and that they had an understanding that they would marry at some future time. However, she continued to go out with friends of her own age. It was after she told him she had visited the Crystal Palace with a girlfriend and had met two young men they had agreed to see again that doubts began to enter his mind.

He became more jealous and possessive and demanded to know why she was spending more time with friends than with him. She responded by saying that she was much younger than him and wanted to spend time with people of her own age. He insisted that at twenty-one years of age she should behave in a more mature manner. Matters came to a head on the night of Friday 26 April when he asked her to spend the weekend with him and she refused, saying she was visiting Peckham with her friends.

At a few minutes before midnight, Jane's mother, who was in bed, heard screams coming from the kitchen. She rushed downstairs to find Jane and Canning struggling on the floor. He leapt to his feet and ran from the house shouting 'I have killed her'. It was then that Mrs Youell noticed blood streaming from two wounds in her daughter's throat and within five minutes she was dead.

Meanwhile, Canning had surrendered at a nearby police station where he made a full confession. He said that he lost control when she had refused to spend time with him that weekend, after which she had told him 'I am not going to stop down here talking to you tonight after mother goes up'. He grabbed a kitchen knife and inflicted the fatal injuries to her throat.

At his trial before Mr Baron Pollock on 27 May, he insisted on pleading guilty. After being sentenced to death he told the judge 'The sentence is just my Lord and I long to die'. There was to be no reprieve and his wish was granted.

*

The crime of Joseph Canning. (*Illustrated Police News*)

TRAGEDY AT BERMONDSEY – A YOUNG WOMAN MURDERED

On 2 July Henry Tickner was hanged for the murder of his wife, Harriet at Send Heath on 11 February.

The Tickners had been separated for some time when Henry visited Harriet on the day of the murder. They argued and he struck her with a bill-hook, fracturing her skull, as a result of which she died twelve days later. There was a history of insanity in his family and at his trial the defence attempted to persuade the jury that forty-two year old Tickner killed his wife in a passion and he too had been insane at the time he committed the crime. However, the jury convicted him of wilful murder but added a strong recommendation for mercy, but this did not save him from the noose.

1896

On 4 April, William James Morgan was hanged for the murder of his wife Martha Morgan on 20 December 1895 at Lewisham.

The Morgans had been married for many years and had seven children. They were a hard working couple; he was fifty-seven and hawked shrimps and she, three years younger, worked at Lewisham Laundry. Strains developed in the relationship and in September 1895 they separated. He took lodgings in Deptford and she lodged on Mill Road. At six fifty five on the evening of the crime, Henrietta Day saw the couple talking to each other close to where Martha lodged. Henrietta was astonished to see him force Martha to the ground on her knees, pull out a knife and slash her throat. She staggered to her feet but collapsed almost immediately.

Frank Barnett, a doctor, arrived to find Martha already dead. The fatal wound was a cut to the left side of her neck which had resulted in the loss of a great deal of blood. Morgan left Mill Road and threw the murder weapon, a black handled table knife,

into a railway arch where it was later recovered by the police. He was arrested later that night and confessed to the murder. He appears to have hoped for a reconciliation but when she refused he murdered her. He blamed his children for the breakdown in the relationship, describing them as workshy and ungrateful. He said

> Yes, I plead guilty. It is all through my sons and daughters. I met my wife tonight and asked her how we were going on. She said Bill is coming directly, and if you interfere with me he will kill you. Then I let her go and out with my knife and stabbed her. I will pay my life for her, but she was a good one. Bill has given me two black eyes and that after keeping him thirty two years.

There was an attempt to argue that at the time of the murder his mind was unbalanced, but this was rejected and his prediction that he would pay with his life proved to be correct.

1897

On 5 January, Henry Brown was executed for the murder of his wife, Fanny on 9 November at Clapham.

In 1893, Fanny Locke who was then twenty-nine years old, married carpenter Henry Brown, who was ten years younger. The couple lived with Fanny's mother, Elizabeth, at 14 Linton Road, Bedford Park, Clapham. He was well known to the police and had a number of convictions for stealing horses, so it was no surprise that a few months after the wedding, he was sentenced to three years penal servitude for the theft of a horse and trap. He was released on 31 October 1896 and returned to his wife but she and her mother thought he seemed depressed and withdrawn.

On the morning of 9 November he gave his mother-in-law a cup of tea, which tasted strange and to which she suspected he may have added poison. Later that day, she heard Fanny, who was in the coal cellar with Brown, screaming for mercy and shouting 'Murder, murder'. Brown next rushed up the cellar stairs and began to beat Elizabeth about the head with a hammer.

Neighbour Harriet Plummer and milkman Samuel Matthews decided to investigate and on peering through the letter box, Samuel could see Brown hitting the elderly woman about the head. Constable Russell arrived to find that Brown had opened the front door, enabling Harriet to take Fanny, who had been savagely beaten about the head and face, into her house for protection.

Fanny said 'My husband has done this. Lock him up'. Brown had stabbed himself in the chest seven times and the knife he had used was recovered at the scene. They were taken to St Thomas's Hospital for treatment, but Fanny died of a fractured skull shortly afterwards. Those treating Elizabeth who was eighty-six years old, were astounded that she survived.

Brown too survived and stood trial, charged with murder, attempted murder and attempted suicide. He was convicted and sentenced to death, but doubts were raised

about his sanity. The Home Secretary arranged for him to be examined by Dr Bryan, the superintendent of Broadmoor Criminal Lunatic Asylum and his predecessor, Dr Nicholson. Both found him to be sane and saw no reason why the death penalty should not be carried out.

1899

On 3 May Frederick Andrews was hanged for the murder of Frances Short on 14 March at Kennington.

Forty-five year old Andrews lived with Frances, a widow nine years his senior, at 4 Garden Cottages, Opal Street, Kennington and the couple made a living by selling vegetables on Newington Market. Frances was a sober and industrious woman and did most of the work, as Andrews was lazy and a heavy drinker who treated her appallingly. He beat her regularly when he was drunk or when demanding money from her with which to buy alcohol. Several days before the murder, Frances told a neighbour, who asked how her face came to be so badly bruised, that Andrews had beaten her when she refused to give him money.

On the day of the murder, neighbours heard the couple quarrelling about his heavy drinking, which was followed by a muted scream and then silence. A short time later he left home pushing his barrow and told them that Frances had left him and had gone to live with her daughter. He was not believed and a group of her friends broke into the house, where her body was discovered hidden under a blanket.

A post mortem, performed by Dr E. E. Roe, Assistant Police Divisional Surgeon, revealed the true brutality of the manner in which Frances had met her death. The fatal wound was a deep cut to her throat, which had been inflicted after she had been grabbed from behind and her head pulled back. He also found evidence of forty stab wounds covering the whole of her body, including several to her eyes which had been inflicted prior to death. The police retrieved the knife used to commit the crime, close to the body.

Andrews was arrested by Constable John Storey a few hours after the discovery of the body, at the Horse and Groom public house on Neal Street, Longacre. He gave what amounted to a confession saying 'It is quite right, I own to it. This is a bad position to be in. I did it in drink. I have been drinking heavily and I had better be hung and get out of it quick'.

At his trial Andrews was far from contrite. He claimed her son had caused much of the friction that existed between the couple and he regretted that he had not killed him also. Having donned the black cap to sentence him to death, Mr Justice Grantham said it was one of the most brutal murders he had known in his long career.

*

On 4 October Robert Ward was hanged for the murder of his two daughters, five year old Margaret Florence and Ada Louisa aged two years, at Walworth on 20 July and became the last person to be executed in nineteenth century Surrey.

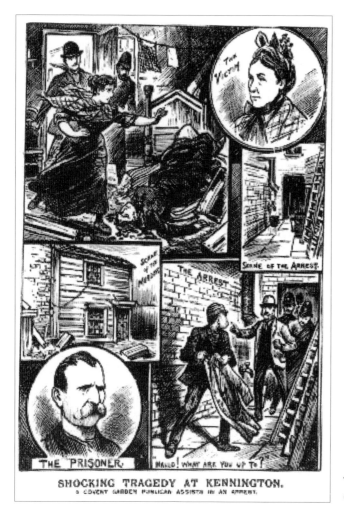

SHOCKING TRAGEDY AT KENNINGTON.
a covent garden publican assists in an arrest.

The Kennington Murder.
(*Illustrated Police News*)

Ward was a twenty-seven year old bricklayer who had been married for six years and the family lived in lodgings at 11 Boundary Lane, Walworth. On the day of the murders he left his workplace at Peckham, telling his workmates he was unwell. He made his way home and asked his wife to go to a local shop and buy a tin of salmon. After she left, he called to the girls who were playing in the street, asking them to come indoors.

Their landlady, Mrs Mills, later told police that she heard the girls run upstairs to the family's rooms. A few minutes later she heard screams and the pitiful cries of one of the girls pleading 'Don't daddy, don't daddy'. Mrs Mills called to their father but there was no reply. The landlady ran up the stairs and when she opened the door to their rooms, she saw Margaret sitting on the bed, her father kneeling by her side with his arm on her shoulder. However, he was not comforting her, for she like her sister had been fatally wounded and died within minutes. Staring at his landlady he cried 'I have done it and I want to die. I think they are both dead and I wish I was as well'. He pointed to a knife on the floor and said that was the weapon he had used.

Ward had also cut his own throat but the wound was superficial and after receiving medical attention he was arrested. He confessed and claimed he had been driven to act as he did by the behaviour of his wife on the previous Sunday, on a visit to the home of her sister at Clerkenwell. There, they had met a soldier named Ollier who had recently returned to England after serving in India for seven years.

When Ward discovered that before travelling overseas, Ollier had been his wife's sweetheart he became enraged, which led to a great deal of unpleasantness. He could not be persuaded that the relationship had ended many years earlier and returned home alone, his wife having refused to accompany him as he was in such an angry mood. She returned home on the following Wednesday, by which time he appeared to have calmed down. However, his jealous rage had been compounded by her refusal to come home with him, and the murders of their children the following day appear to have been committed in revenge for his wife's behaviour.

Overleaf: Robert Ward, the last man to be executed in nineteenth-century Surrey, was guilty of a particularly heinous crime. (*Illustrated Police News*)

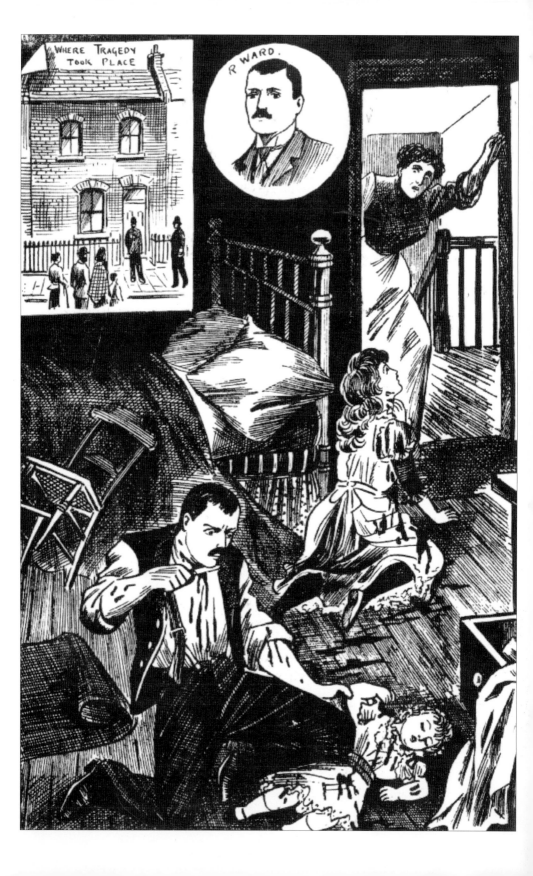